IMAGES
of America

HARRISONBURG

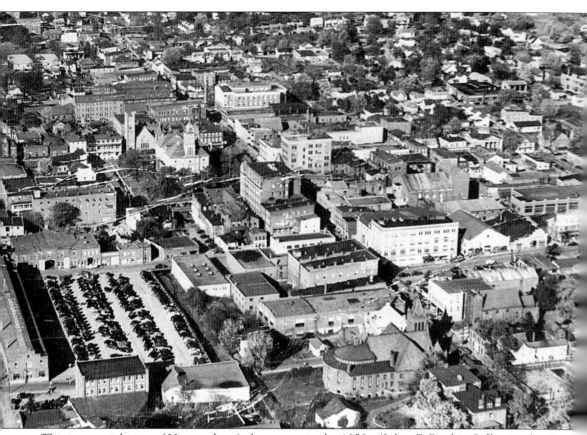

This is an aerial view of Harrisonburg's downtown in the 1950s. (Julius F. Ritchie Collection.)

IMAGES
of America

HARRISONBURG

Cheryl Lyon and Scott Hamilton Suter

ARCADIA

First published 2003
Reprinted 2003, 2004, 2005

Published by Arcadia Publishing
Charleston SC, Chicago IL, Portsmouth NH, San Francisco CA

Printed in Great Britain

Library of Congress Catalog Card Number: 2003107145

For all general information contact Arcadia Publishing at:
Telephone 843-853-2070
Fax 843-853-0044
E-mail sales@arcadiapublishing.com
For customer service and orders:
Toll-Free 1-888-313-2665

Visit us on the internet at http://www.arcadiapublishing.com

Dedicated to the Memory of Julius F. Ritchie (1910–2002).

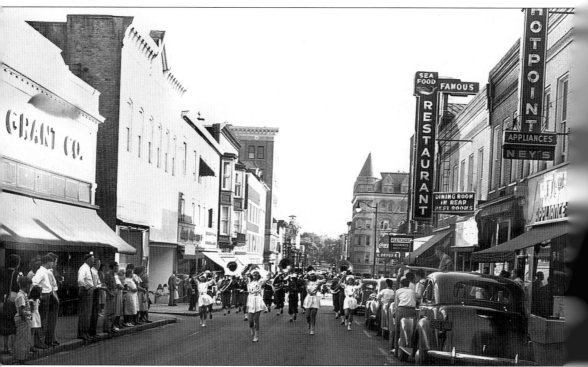

A 1950s parade is pictured as it heads north on Main Street just past Court Square. (Julius F. Ritchie Collection.)

CONTENTS

ACKNOWLEDGMENTS

This book would not have been possible without the generous assistance of several individuals who granted us access to their collections. Lura Ritchie kindly allowed us to pore through her late husband Julius Ritchie's vast collection of images. Mr. Ritchie gathered the history of his native city throughout much of his adult life and the community has benefited from his efforts on many occasions in the past. We have dedicated this book to his memory in recognition of his passionate pursuit of historic photographs. We also wish to thank Jeffrey S. Evans, Greg Evans, Dwight Hartman, and several private collectors who graciously allowed us use of their holdings. We also thank the following institutions for permitting the use of their archival material: the City of Harrisonburg, Eastern Mennonite University, the Harrisonburg-Rockingham Historical Society, James Madison University, and Massanutten Regional Library. Numerous individuals helped in a variety of ways, and we extend our gratitude to Terry Barkley, Chris Bolgiano, Harry Lee Depoy, Janet and Earl Downs, Ruth Greenawalt, Harold Huber, Dana Luck, Stanley Suter, and Nick Whitmer.

SOURCES CONSULTED

Bassford, Kirby S. "Tommy." *Landmarks and Personages of Old Harrisonburg*. Harrisonburg, Virginia: privately printed, 1944.

———. *Railroads of the Shenandoah Valley*, *"The Old Church on the Hill," The Churches of Harrisonburg*. Harrisonburg, Virginia: privately printed, 1946.

———. *Sketches of Harrisonburg, 1840–1940*. Harrisonburg, Virginia: privately printed, n.d.

———. *Sketches of Harrisonburg: Schools and Firemens' Organizations, 1833–1942*. Harrisonburg, Virginia: privately printed, n.d.

———. *The Evolution of Harrisonburg, 1780–1945*. Harrisonburg, Virginia: privately printed, 1945.

Price, C.G. Sr. "My Recollections of Harrisonburg at the Turn of the Century." *The Rockingham Recorder* 3, no. 1 (April 1979): 24–38.

Showalter, Noah D. *Atlas of Rockingham County, Virginia*. Harrisonburg, Virginia: by the author, 1939.

Wayland, John W. *A History of Rockingham County, Virginia*. Dayton, Virginia: Ruebush-Elkins Company, 1912.

———. *Historic Harrisonburg*. Harrisonburg, Virginia: privately printed, 1942. Reprint, Harrisonburg, Virginia: C.J. Carrier Company, 1990.

INTRODUCTION

In 1949, the venerable historian John W. Wayland published this observation in his *Historic Harrisonburg*: "On Sunday evening another of the old landmarks succumbed to the persistent efforts of Young America, whose bump of destructiveness seems to be swelling to extraordinary dimensions at this time. The old church upon the hill, after standing siege, which began at an early hour, until 4 o'clock, tumbled with a crash."

Wayland's point is clear; however, the remarkable feature of this quotation is that he uncovered it in the city's newspaper *The Old Commonwealth* from November 22, 1865. Accounts such as these can be found in publications throughout Harrisonburg's history, for that history is one of change, and change often necessitates demolition. That fact alone merits a book such as this, but the story of Harrisonburg also involves a dedication to "progress," and that record, too, is evident in the following pages.

First settled in 1737 by members of the Thomas Harrison family, the town of Harrisonburg was recognized by the Virginia House of Delegates in 1780 as the seat of the newly formed Rockingham County. The act of establishment acknowledged that Harrison had "laid off fifty acres of his land [. . .] into lots and streets which would be of great advantage to the inhabitants of that county if established as a town for the reception of traders." Indeed, the newly accepted town did become the crossroads of important trade routes that emerged in the central portion of the Shenandoah Valley; the crossroads, in fact, was the city's Court Square. Known as Rocktown in its early days, after the Commonwealth's recognition the town came to be called Harrisonburg. The town grew rapidly in its first 20 years; the 1798 tax records specify 71 structures within the town limits. Growth was to become a significant part of the city's history.

Harrisonburg's location in the midst of the agriculturally rich Shenandoah Valley solidified its place as an economic center by the early 19th century. At the outbreak of the Civil War, Harrisonburg's economy was strong, and a growing number of merchants who catered to the needs of the city's population, as well as those of the outlying farmers, bolstered the city's financial base. Primarily self-sufficient, the county's farmers relied on merchants to handle their surplus crops and rural artisans often commissioned their wares through businesses such as Henry Shacklett's general merchandise store on Court Square. Following the Civil War a depression affected the region; however, always looking forward, by the 1890s a group of prominent Harrisonburg businessmen proclaimed a grand industrial future for the town. Functioning as the Harrisonburg Land and Improvement Company, the group offered for sale over 200 lots on the north end of the city hoping to attract buyers for both the business and residential sections of their tract. Although the predicted "boom" did not arrive with a resounding roar, life in the city continued at its brisk pace.

By 1916, Harrisonburg incorporated as an independent city. The city's growth was accompanied by a need for more municipal services; new power plants, an increased police force, and four vigilant fire companies brought protection and stability to Harrisonburg. But

steady growth did not mean prosperity for all. By the 1950s Harrisonburg's city council felt that the lower income sections of the city, primarily located in the northeast section, could be better used if they were turned from mixed housing and business into new streets, parking facilities, and business sites. When an urban renewal plan was proposed in 1955, city residents passed the measure by a slim 46-vote margin. Although not blessed with an overwhelming mandate, the project proceeded, and structures within the boundary of Rock Street, Broad Street, Johnson Street, and North Main Street were demolished. Naturally, the effects of the project, both positive and negative, remain evident more than 40 years later.

The late 1950s also witnessed a transportation revolution in the city. Concerned about the amount of truck traffic barreling through downtown, city authorities pushed for, and received, a bypass of Harrisonburg. In 1960, a 7.5-mile stretch of highway that would eventually become a part of Interstate 81 skirted the city's eastern boundary, passing through the rolling farmland there. Ironically, the bypass around Harrisonburg worked too well, and by the 1970s rapid development near the interstate lured prominent businesses from downtown to U.S. Route 33 and a newly built mall. By the mid-20th century, then, planned growth, urban renewal, and nearby Interstate 81 had transformed Harrisonburg from a thriving downtown of mostly locally owned businesses and residences into an expanding community of nationally known and corporately owned chain stores.

As *The Old Commonwealth* quotation above suggests, the move from a small community in the 18th century to a metropolis in the 21st century could not have occurred without the loss of buildings and features that, to many, exemplified the city they called home. Those landmarks, perhaps deemed insignificant in the face of progress, are often the sources of memories and, thus, the foundation of the spirit of a community. In 1941, Harrisonburg's *Daily News Record* recounted the recent return of two brothers who had not visited the city since departing in 1893. The brief article reported that the "Gassman boys," as they were fondly remembered, "were much impressed by the modern buildings but were a little saddened to find so many of the landmarks of their boyhood days either razed or so changed as not to be recognized." In selecting photographs for this collection we have attempted to defy the "bump of destructiveness" by providing images that reveal a history of Harrisonburg not often chronicled. We hope, too, to spark memories of a Harrisonburg of the not-too-distant past, so that we may all realize the value of preserving a shared community.

One

THE EVOLUTION OF
COURT SQUARE

No remnant of Harrisonburg's original Court Square is visible on the 21st-century landscape. The original two and a half acres deeded by Thomas and Sarah Harrison in 1779 for public buildings are all that remain of those early marks on the land. First used in 1780, the initial courthouse on the public square was a 20-by-30-foot building of horizontal log construction. By 1791 a stone structure was planned for the town square. Situated north of Market Street, which bisected the square in those days, that courthouse would stand until 1833. With that aging building declared unsafe in 1833, a brick structure was built, standing in use until 1874. The third county courthouse, it was the first to be photographed. A rich era of photography arrived with the erection of the fourth courthouse and it appears in numerous images along with the buildings surrounding the square. By 1897, when the current Rockingham County courthouse was completed, the city's population had increased dramatically, bringing with that growth a desire for change.

The images in this section present a composite picture of the evolution of a single spot in the city of Harrisonburg. From the 1833 courthouse to the modernistic design of a Denton's Furniture store façade, the photographs tell a story of what was Court Square and what it became by the middle of the 1960s. Early images reflect the intermingling of residential and commercial structures, occasionally within the same building. As time moves along in these shots, newer brick houses replace old ones of stone or log, only to be replaced by modern business buildings or parking lots. While no collection of photographs could offer a complete picture, the following provides a thorough representation of the evolution of Harrisonburg's Court Square.

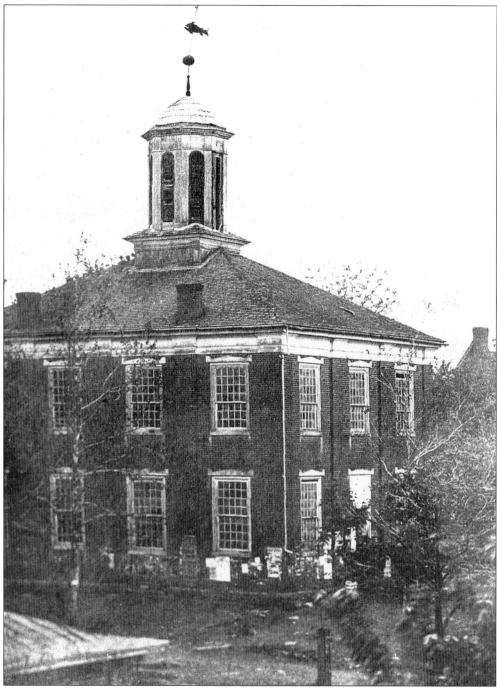

The third courthouse to stand on the public square in Harrisonburg, this structure was the first to be photographed. Constructed in 1833–1834, the building stood until 1874 when it was declared unsafe for the public by Judge Charles T. O'Ferrall. The brick courthouse was erected for approximately $5,000 and bore witness to the years of the Civil War when it served as a comfort station for wounded and weary soldiers as well as a political prison for others. (Massanutten Regional Library Collection.)

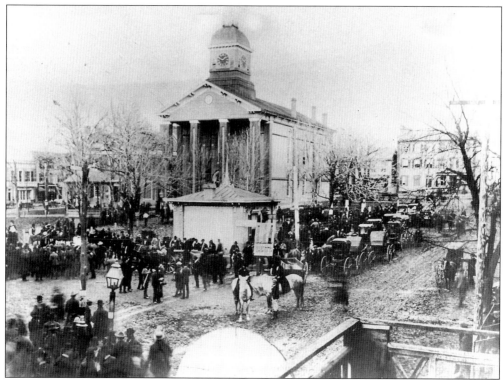

Though it stood for only 22 years (1874–1896), Rockingham County's fourth courthouse was an impressive brick structure whose cupola featured the town clock. With a 45-foot façade and a depth of 85 feet, the building brought a significantly new look to Court Square. This image offers a glimpse of "court day," a time when public and personal business was transacted and many county residents made their monthly visit to the city. (Julius F. Ritchie Collection.)

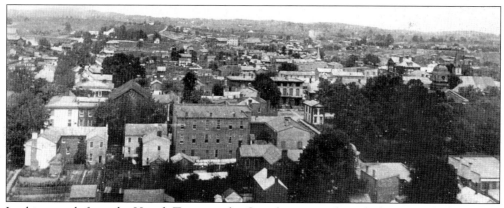

Looking north from the Houck Tannery, the Courthouse cupola with the town clock rises out of the tree-covered Court Square on the right of this early 1890s photograph. The backs of the buildings shown along West Market demonstrate the intermingling of residences and businesses. The view also offers a rare look at the small council building on the northwest corner of the Courthouse lot. It is located just to the left of the stand of trees. (City of Harrisonburg Collection.)

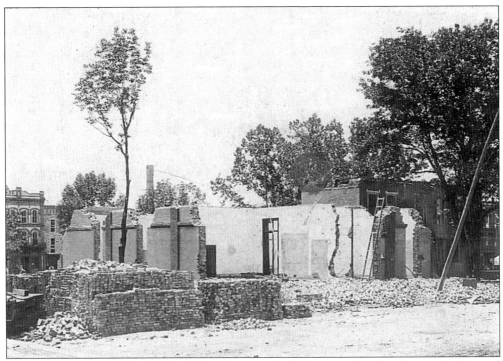

By 1895 Rockingham County needed a larger judicial home, and Judge George G. Grattan approved the county board of supervisors' request to build a new courthouse. Above, the 1874 structure is reduced to a few walls, while below, the new building is well under way. Highlighted by "impressive Masonic ceremonies" lasting nearly an hour, the cornerstone was laid on October 15, 1896. The estimated crowd of 4,000 enjoyed musical selections by the Stonewall Brigade Band and a group of orphans from the Masonic Home in Richmond. (Harrisonburg-Rockingham Historical Society Collection; Julius F. Ritchie Collection.)

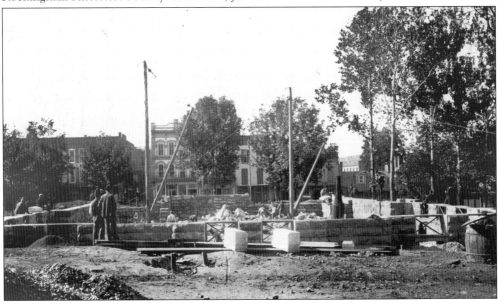

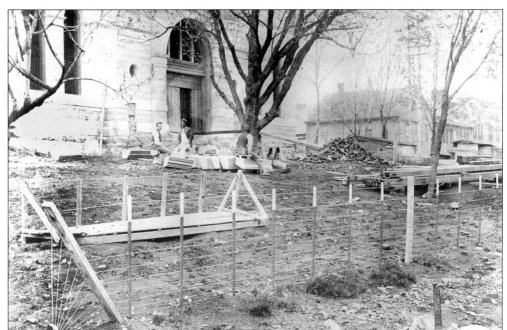

Originally designed as another brick edifice with terra cotta trimmings, the county supervisors altered the plan, choosing instead to construct the building with Indiana limestone. Although this alteration added another $15,700 to the cost, the decision produced an impressive courthouse that has stood longer than any other official building in the square. At the building's dedication Sen. John W. Daniel, perhaps responding to grumbling about the costs of the project, exhorted the large crowd to "Let not its cost mar the pleasure of your contemplation." The final tally was $96,826.24. (Julius F. Ritchie Collection; Greg Evans Collection.)

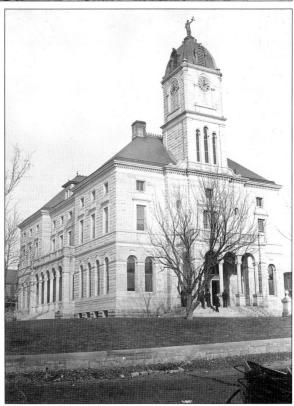

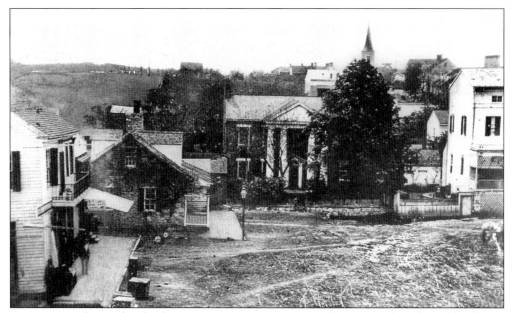

Prior to 1870 the south side of Court Square was a mixture of business and residential buildings. Asher Waterman's stone house, the second-oldest dwelling in the city, and Judge James Kenney's Federal style brick home are clearly visible, while businesses such as Lupton's clothing store, B.S. Van Pelt's liquor establishment, D.M. Switzer's commercial buildings, and various law offices are less obvious. Like Switzer, J.L. Sibert had both his home and his business on the square; he owned the former tavern known as the Washington House, which was built sometime around 1820. (Julius F. Ritchie Collection.)

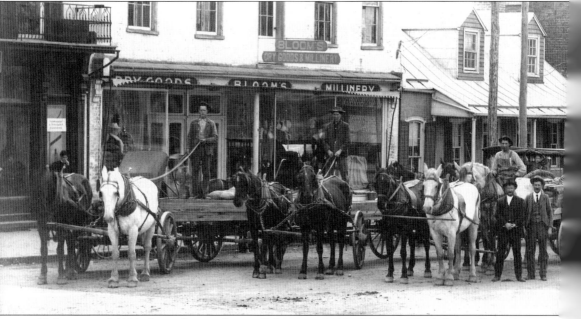

Taken around 1900, this gathering shows off the post-1870 buildings on the left as well as a slice of Harrisonburg's residents and their horses. Although the specific occasion for this assemblage is unknown, each of the wagons is loaded with milled lumber, suggesting that the group is about

14

When compared to the view shown in the top photograph on the opposite page, this image shows clearly the damage caused by a devastating fire on Christmas morning 1870. Following the fire much discussion ensued when both Sibert and Switzer proposed to move the foundations of their new buildings nearly 20 feet forward into the square. This rare photograph shows that all the foundations were indeed moved forward, despite a legal injunction to prevent it. (Massanutten Regional Library Collection.)

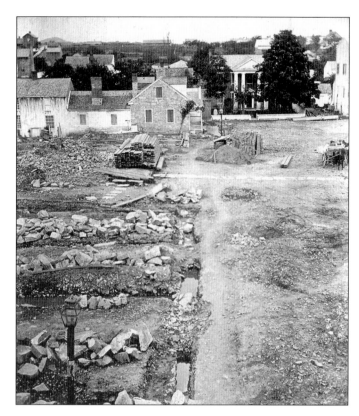

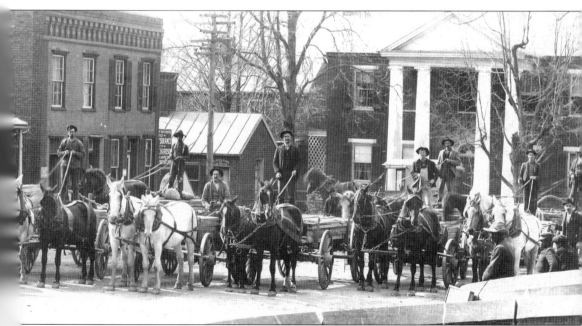

to embark on a special building project. It's worth noting that Bucher's lumber mill was located just east of Court Square on Elizabeth Street. (Greg Evans Collection.)

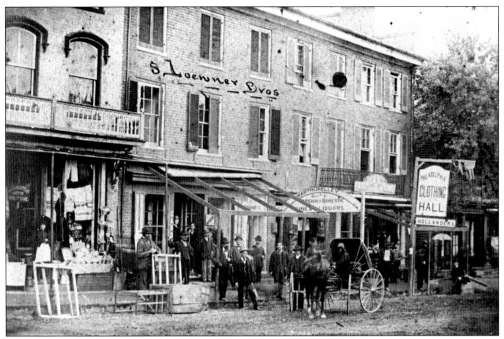

Just south of the corner with East Market Street, Sol Loewner and his brother Abe operated a store in a portion of the Spotswood Building. This 1870s photograph demonstrates the variety of stores along Main Street by this point in the 19th century. (Julius F. Ritchie Collection.)

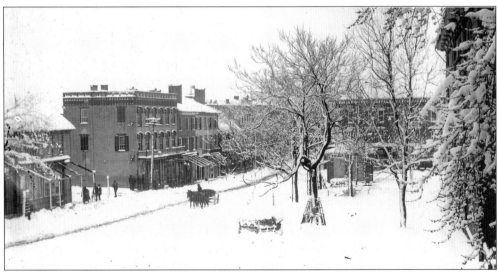

A snowy landscape highlights the buildings along the southeast side of Court Square. The large building on the corner housed the store of Herman Wise who billed himself as "The Great Price Cutter." His wares included shoes, boots, and other leather products, along with home furnishings. (Julius F. Ritchie Collection.)

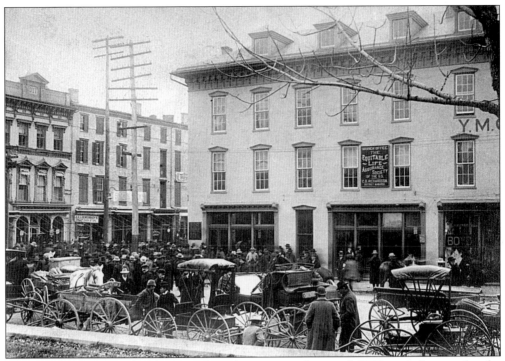

J.L. Sibert's post-1870 building stood until it was razed around 1903 to make way for the First National Bank building. This turn-of-the-century court day photograph demonstrates the variety of ways these older buildings were used. The Sibert building was home to the YMCA, a bookstore, and an insurance company as well as other businesses. (Julius F. Ritchie Collection.)

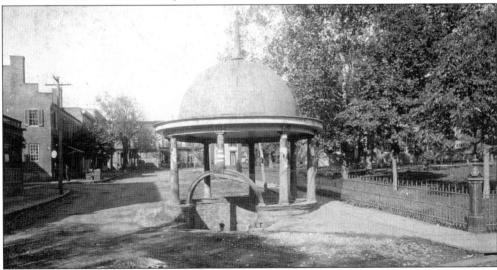

When Thomas Harrison settled in the area of Harrisonburg, two strong-flowing springs ran near to each other. Building his house over one, the other ran not far away on the site of what was to become Court Square. According to the *Rockingham Register*, at that time the "big spring" was "covered with rocks, many of the cliffs being so tall that a horse could hide behind them." Although the site was eventually cleared and covered, these formations may have given Harrisonburg its early name of "Rocktown." (Greg Evans Collection.)

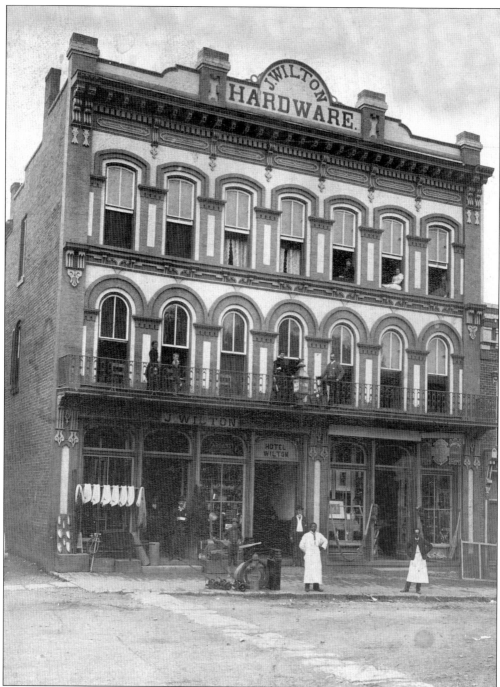

Joshua Wilton, a Canadian who came to Harrisonburg in 1865, worked with Philo Bradley at the foundry and opened his own hardware store in 1868. This grand building, which stood on south Court Square, housed his business along with several others throughout the years. The upper levels of the structure were operated as the Clarendon Hotel and the storefront at right was home to a bookstore. In its final years the magnificent building was home to a Virginia ABC store and the Helbert Hotel. The site is currently a parking lot. (Greg Evans Collection.)

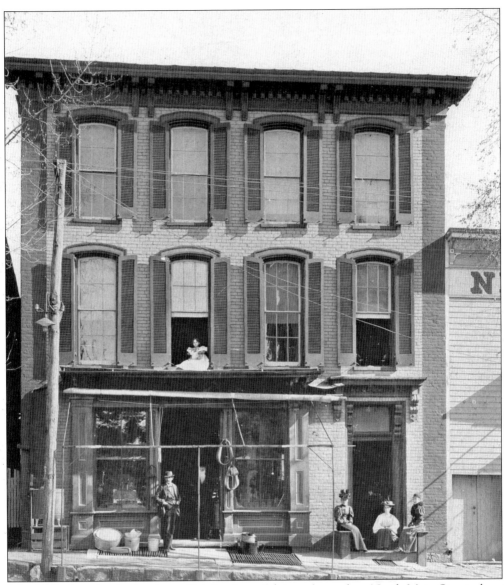

John P. Burke poses in the door of his hardware business located on North Main Street along the east side of Court Square. Young Harriet Baer, daughter of the building's owner, Mrs. Newton Baer, sits in the second-story window. The structure's upper floors served as the Baer family dwelling. (Harrisonburg-Rockingham Historical Society Collection.)

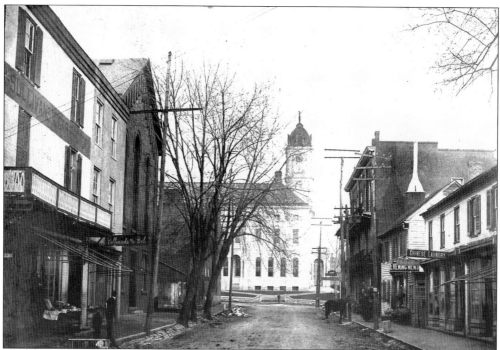

This pair of images taken from nearly the same location indicates the changes that took place along many city streets. While the courthouse remains unchanged at the east end of West Market Street, the businesses have changed as have a few of the buildings. Taken around the turn of the 20th century, the photo above shows Sullivan's Cigar factory with a billiards hall below on the left, and the offices of Harrisonburg's newspaper, *Evening News*, as well as Lieu B. Ying's Chinese laundry on the right. By around 1915, when the shot below was taken, brick buildings, including a mercantile built by Judge John Paul, had replaced the wooden structures on the south side of the street. (Massanutten Regional Library Collection; Julius F. Ritchie Collection.)

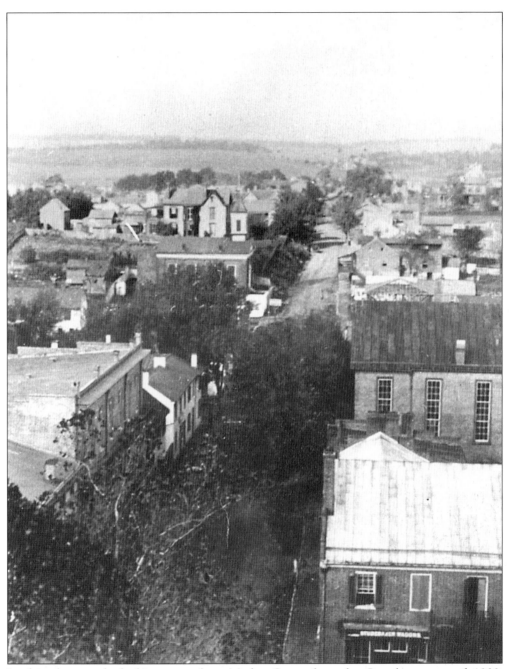

In this photograph, looking west along Market Street from the Courthouse around 1900, one can easily see the development of the city along that important route. Two churches are visible in this image: the Methodist church, which was located in the long brick building in the center of the photograph, and the Catholic church further down the street on the south side. The Catholic structure burned in 1905; the current building on North Main Street was constructed in 1906–1907. The Methodist building was eventually used as a garage and then demolished to make room for the current Rockingham Motor Company building. (City of Harrisonburg Collection.)

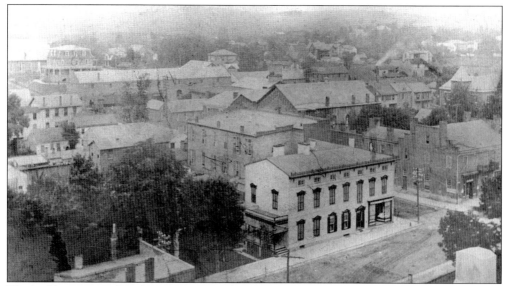

The building pictured in the center of this photograph was long known as the John Sites house. Recalling the 1820s, Maria Carr described the house as "a long brick building" with Sites' store located in the corner of the structure. Taken in the 1880s, the image does show a storefront in the building's facade. In 1936, the city purchased this house and remodeled it—inside and out—to serve as the municipal offices. It fulfilled this purpose until the mid-1950s when the offices moved and the historic house was demolished. (Julius F. Ritchie Collection.)

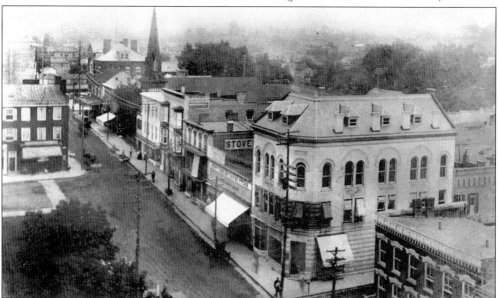

Taken from atop the First National Bank Building, this view shows the commercialized stretch of North Main Street along Court Square's east side. The three-story structure on the corner, built by A.M. Newman in 1897, housed the Rockingham National Bank and later the offices and studios of radio station WSVA. The buildings along the street have been home to numerous businesses including J.C. Penney, Woolworth's, and McCrory's. The steeple of the Presbyterian church marks the later location of W.T. Grant and, later still, the Advance store. (Julius F. Ritchie Collection.)

Built by Andrew B. Irick on the northwest corner of Court Square in 1858, this building initially housed the Bank of Rockingham. Irick was president of that institution. Known by those who remember it as the Warren Hotel, the building was identified earlier as the Exchange Hotel. Harrisonburg attorneys Edward S. and George N. Conrad maintained their offices in the historic structure and Dr. Frank L. Harris practiced dentistry there. The building was razed in 1964 and paved as a parking lot. (Harrisonburg-Rockingham Historical Society Collection; Julius F. Ritchie Collection.)

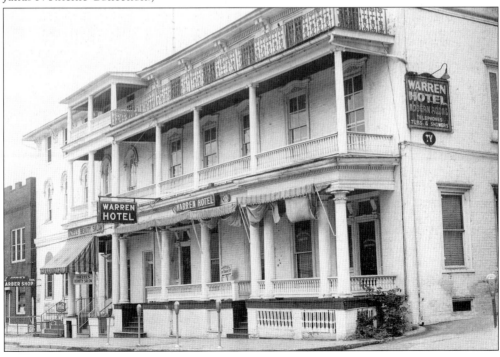

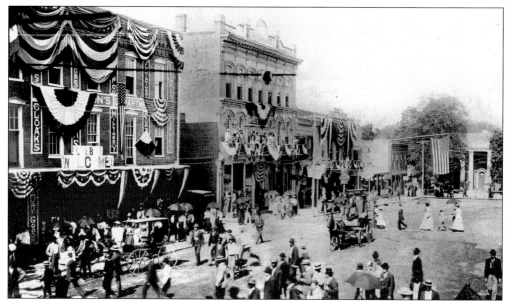

Demonstrating the exuberance of an Independence Day celebration in Harrisonburg, this shot of south Court Square also provides a unique view of the Sibert Building when merchants William Loeb and Son occupied it. Reporting on the city's July 4th preparations in 1893, a writer for *The Rockingham Register* noted, "The stores and other business places downtown were decorated with flags and bunting, and in the afternoon a dozen immense 40 foot flags . . . were suspended across the streets at the most public places." (Harrisonburg-Rockingham Historical Society Collection.)

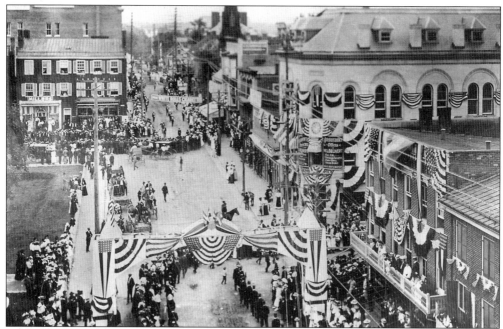

In a similar show of patriotic support, Harrisonburg merchants decorated Court Square for the State Convention of Firemen, which was held in the city in 1905. Clearly the parade route is lined with appreciative residents. (Julius F. Ritchie Collection.)

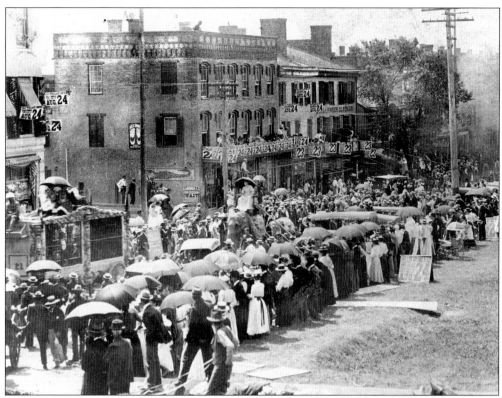

Perhaps showing his pride in his native city, in the 1940s Kirby Bassford recalled that at the turn of the century "Harrisonburg was considered by circus people to be the best show town in the South." The performers and animals often paraded around Court Square, whetting appetites for the extravaganza to be witnessed under the big top. Circuses held in the city were advertised widely throughout neighboring West Virginia and over the Blue Ridge in eastern Virginia. The crowds of people dressed in their finery and the number of wagons and carriages congesting the square attest to the popularity of the circus and to the role Harrisonburg played as a "circus town." (Julius F. Ritchie Collection.)

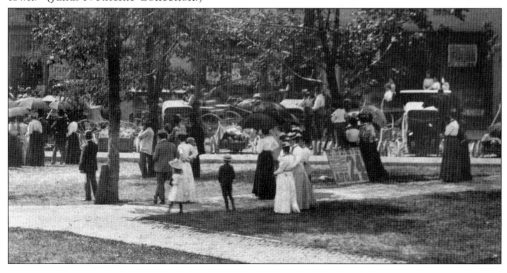

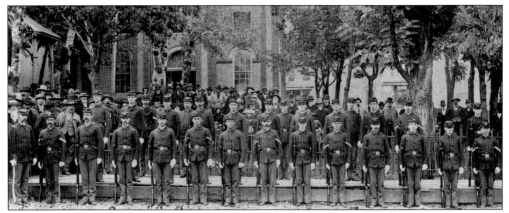

Posed in front of the 1874 courthouse, the members of Company C, Virginia Volunteers demonstrate their readiness to serve their state and country. Along with a glimpse of the courthouse, this image indicates the position of Eshman's bandstand on the left and the board walks that once lined the streets of the city. (Massanutten Regional Library Collection.)

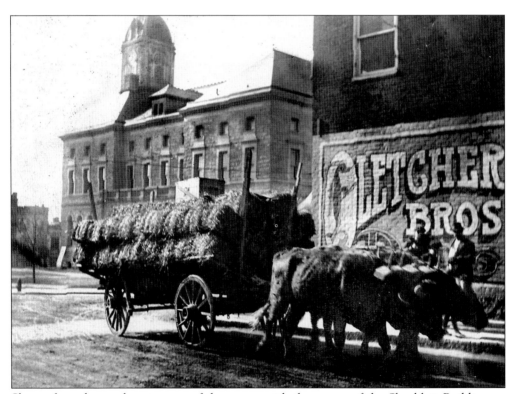

Shown from the northeast corner of the square with the corner of the Shacklett Building on the right, this interesting "slice of life" shot from 1905 juxtaposes a commonplace ox cart with the stately Courthouse. The Fletcher brothers, pharmacists, occupied the Shacklett building until the 1940s. (Massanutten Regional Library Collection.)

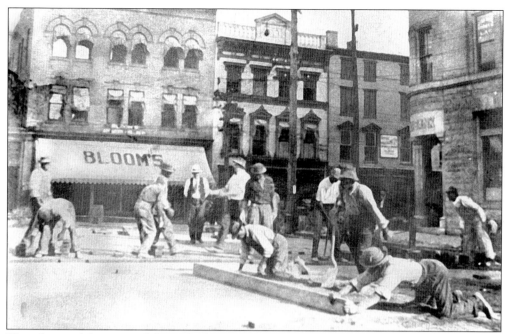

The advent of the automobile made changes necessary to the streets around the square. These 1916 photographs reflect the labor required for paving the streets with vitrified brick. Below, a steam-powered cement mixer belches smoke as workers prepare the street's surface for the bricks. (Julius F. Ritchie Collection; Harrisonburg-Rockingham Historical Society Collection.)

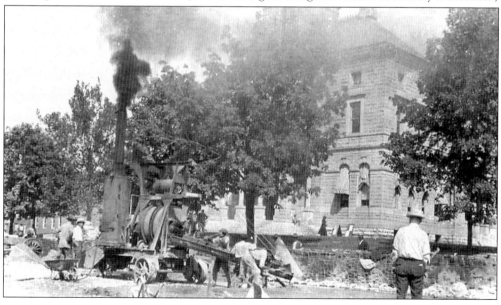

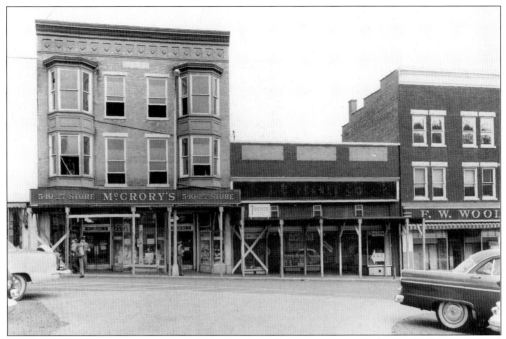

By the 1920s nationally recognized store names began to appear alongside those of local merchants. This image from the 1950s shows McCrory's in the process of remodeling their storefront to keep up with the changing times and fashions. (Julius F. Ritchie Collection.)

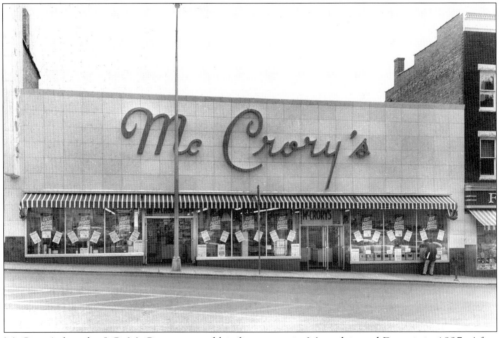

McCrory's founder J.G. McCrory opened his first stores in Memphis and Detroit in 1897. After remodeling the façade in 1950s, the Harrisonburg store maintained this look into the 1970s. After housing a number of other businesses, the building was partially razed in the 1990s. (Julius F. Ritchie Collection.)

Located on the site of the James Kenney house on the southeast corner of the square, J.S. Denton's four-story furniture store took the place of one of the buildings that survived the 1870 Christmas fire. J. Simon Denton opened for business in Harrisonburg in 1905 and built this building in 1922–1923. (Julius F. Ritchie Collection.)

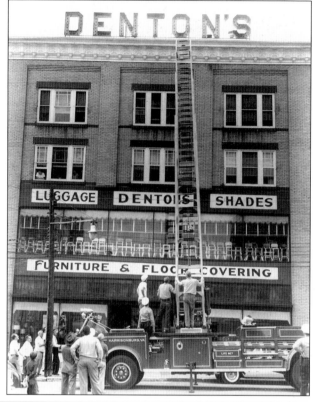

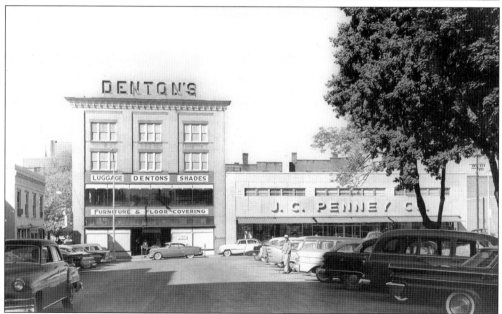

J.C. Penney Company's first store in Harrisonburg was located at 28–30 North Main Street, along the same stretch as Woolworth's and McCrory's. In July 1957, the store opened across the square on the site of the Sites House/Municipal Building, marking a move by some of the city's retailers into more modern facilities. (Julius F. Ritchie Collection.)

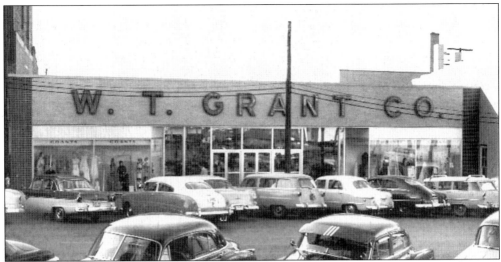

Following the trend set by Denton's and Penney's, W.T. Grant Company moved their store to Court Square in the early 1950s. Originally located just off the square on North Main Street, the company purchased the Waterman House and D.M. Switzer's old building, tearing them down to make way for this nondescript brick structure. In the 1960s, the company took advantage of the city's urban renewal program and relocated to a shopping center on North Mason Street. (Harrisonburg-Rockingham Historical Society Collection.)

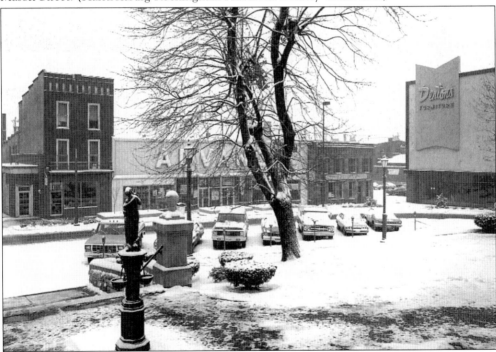

By the early 1970s the south side of the square had taken on this stark appearance. Advance Auto Parts store had moved in when the W.T. Grant store moved out and Denton's had attached a 1960s modern façade. Only the Grattan Building in the corner and another business building reminded citizens of an earlier age of architecture. (Harrisonburg-Rockingham Historical Society Collection.)

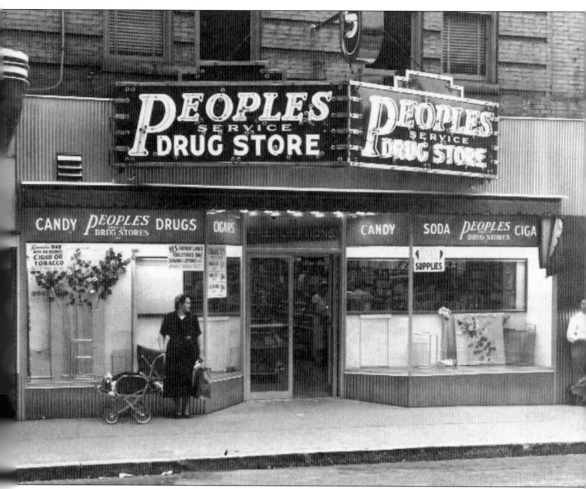

Many city residents will recall the People's Drug Store, which was located in the Spotswood building just off Court Square on South Main Street. Opening for business in 1953, this branch remained open through the mid-1960s when the company opened a new store in the "renewed" section of the city. (Harrisonburg-Rockingham Historical Society Collection.)

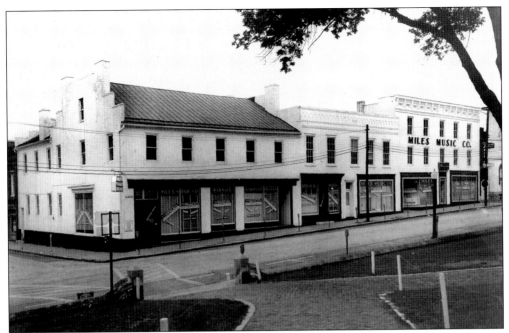

Originally lined with houses, this portion of the west side of the square witnessed many changes throughout the years. For instance, the Dold House on the corner replaced a stone one where Archibald Rutherford, a gunsmith, lived in the early 19th century. In this 1950s image the entire row is slated for demolition. (Julius F. Ritchie Collection.)

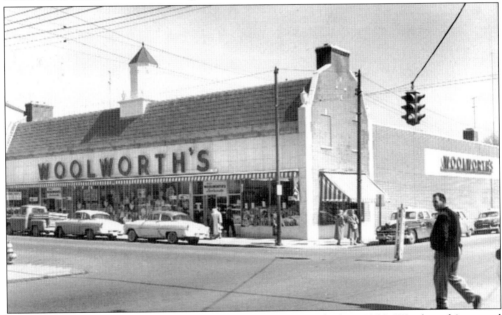

Formerly located on North Main Street along the square, in the late 1950s Woolworth's moved directly west, reopening in this modern building with a curious cupola and gambrel roof design. Taking the place of the Miles Music store and the adjacent building in the photo above, the building filled a considerable space along west Court Square. (Harrisonburg-Rockingham Historical Society Collection.)

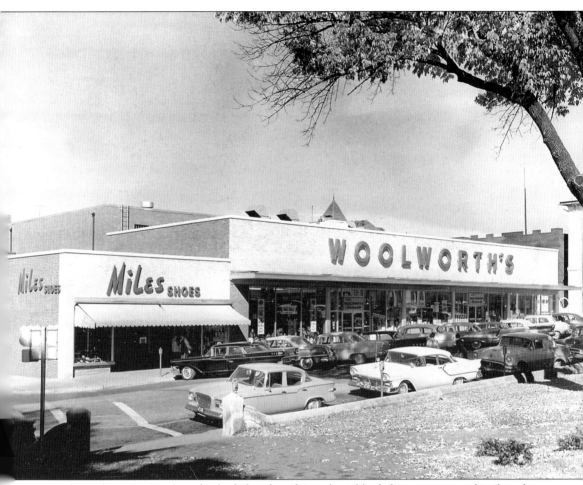

By the early 1960s Woolworth's had abandoned its colonial look for more stream-lined modern lines as had the Miles Shoes building. Both buildings remain on Court Square today in only slightly altered form. (Julius F. Ritchie Collection.)

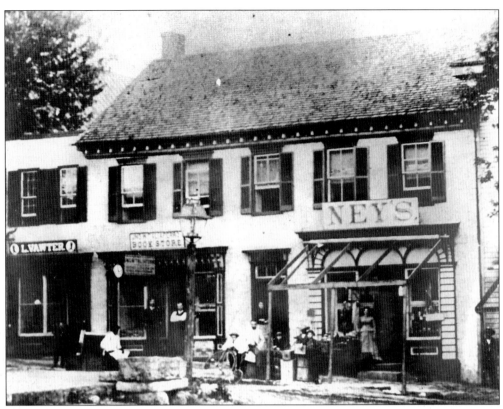

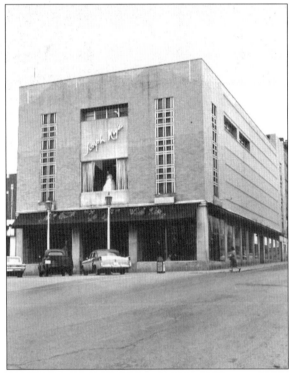

Joseph Ney immigrated to the United States from Germany in 1869, arriving in Harrisonburg in 1872 when he clerked in his brother B. Ney's store. Initially opening a confectionary, Ney settled into the dry goods business in this shop located on the east side of North Main just across from the Shacklett building. (Julius F. Ritchie Collection.)

Although Joseph Ney died in 1916, two of his sons, Alfred and Eddie, carried on the business. In the 1950s they purchased the Shacklett building on the northeast corner of the square, demolished it, and built the imposing structure shown here. This photograph was taken in1962. (Harrisonburg-Rockingham Historical Society Collection.)

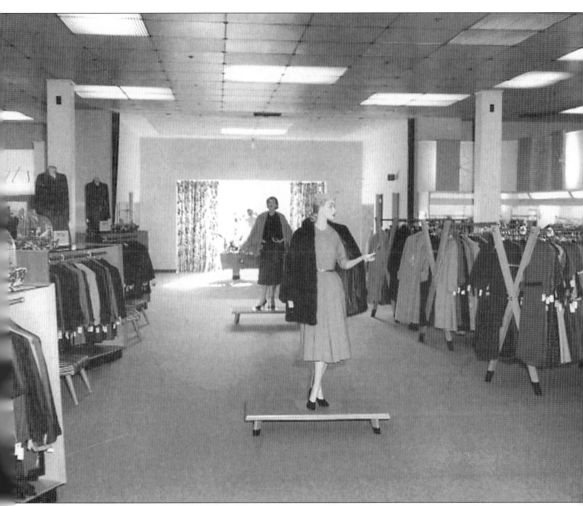

Taken in the early 1960s, this image of a selection of Joseph Ney's ladies' apparel offers a rare glimpse at the interior of one of Harrisonburg's most well known clothing stores. Looking toward the large window that offered a view of Court Square, we also find a statement on the fashions of the day. Many city residents will remember riding the elevator at Joseph Ney's; it offered the uniquely elegant services of a uniformed doorman to press the proper buttons. (Harrisonburg-Rockingham Historical Society Collection.)

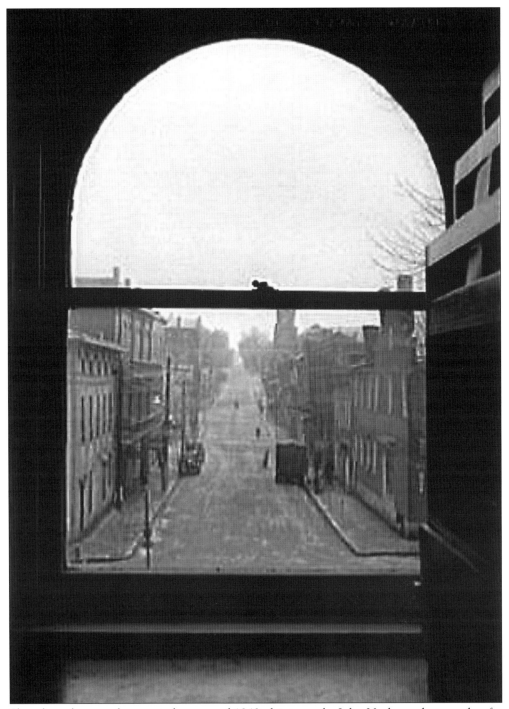

Shot through a courthouse window around 1940, this image by John Vachon, photographer for the Farm Security Administration, offers a wistful look at West Market Street. (Library of Congress, Prints & Photographs Division, FSA-OWI Collection.)

Two

THE BUSINESS OF EVERYDAY LIFE

Harrisonburg is a business-oriented town; it has been since the late 18th century. After the city was recognized as the seat of Rockingham County in 1780, the Great Wagon Road from Philadelphia was straightened and pointed straight through Harrisonburg. Moreover, a road heading east to the Piedmont and Tidewater sections of Virginia assured Harrisonburg's place in the early markets of the region. The photographs here, of course, are from a later period; however, they attest to the early importance of the city as a trade center. The longevity and diversity of businesses in the city also point to the importance of Harrisonburg as a business center in the Shenandoah Valley.

J.P. Houck's story may best signify the important role of commerce in the community. Houck moved to Harrisonburg after spending 14 successful years as a merchant in the town of Milnes (now Shenandoah) in Page County. Lured by what he recognized as the greater potential of Harrisonburg, he arrived in the city in 1880, and soon became an important figure in the city's business world. Along with his own businesses, he also was a member of the group that founded the Harrisonburg Land & Improvement Company. In 1890, that organization sought to foster a "boom" in the city and purchased a large parcel of land on the north side of the city. Inviting businesses to relocate and encouraging local establishments to join them, the company did lure several businesses to their property. Ultimately, most of the projects failed; however, Houck's involvement and the project itself are indicative of the business spirit of the city. As Houck's example demonstrates, innovation and perseverance seem to be hallmarks of the city's businesses. These traits often lead to change, and change is evident in the photographs reproduced here. You may, however, see a few familiar sights that recall earlier days of Harrisonburg's business world.

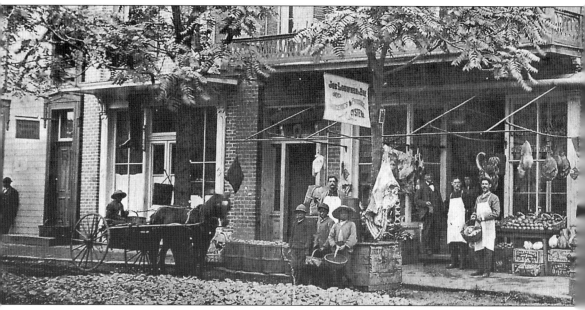

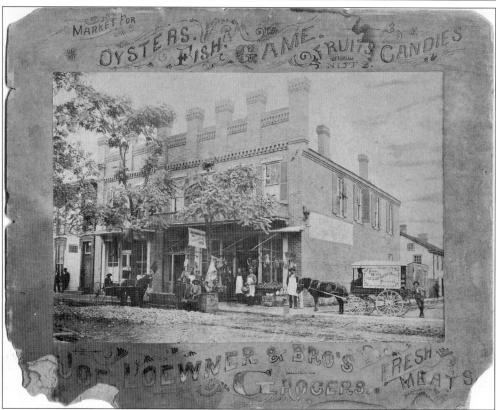

The store was located on the northeast corner of North Main and East Wolfe Streets and apparently sold nearly any grocery item one could want. A 1902 advertisement reads, "Fresh oysters. When we say fresh we mean fresh, and that's the kind you want. As cheap as the cheapest." (Harrisonburg-Rockingham Historical Society Collection.)

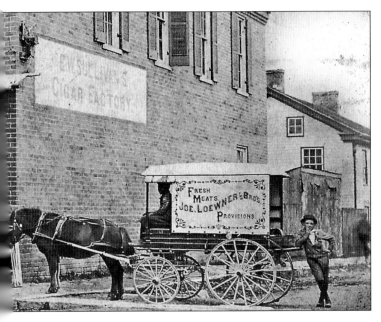

This fascinating photograph of the Joseph Loewner and Brothers store and its employees is perhaps one of the most interesting shots of a Harrisonburg business. From the bananas, to the sides of meat, to the hand-built baskets held by patrons, the details of this image are stunning. Take the time to look closely. (Harrisonburg-Rockingham Historical Society Collection.)

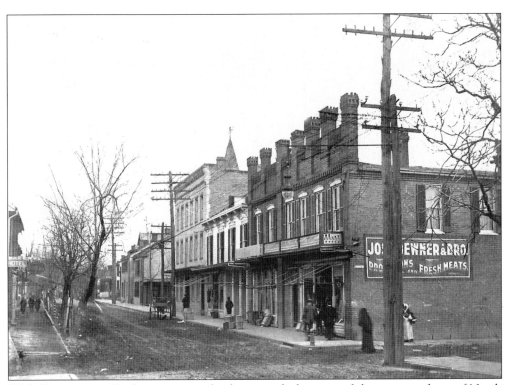

With the Loewner Brothers' store in the foreground, this turn-of-the-century photo of North Main Street also shows the National Hotel and the spire of the Jewish temple in the distance. This block of buildings was razed during the urban renewal of the late 1950s. (Massanutten Regional Library Collection.)

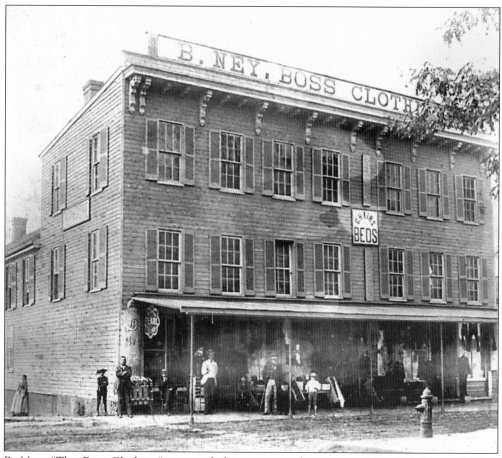

B. Ney, "The Boss Clothier," operated this store on the corner of North Main and West Elizabeth Streets from 1874 until his death in 1915. Baruch Ney emigrated from Germany in 1865, arriving in Harrisonburg shortly afterward and setting to work for Leopold Wise in his downtown store. After operating a confectionery store for a brief period, he specialized in men's wear after moving to this store. This image was taken around 1890. (Harrisonburg-Rockingham Historical Society Collection.)

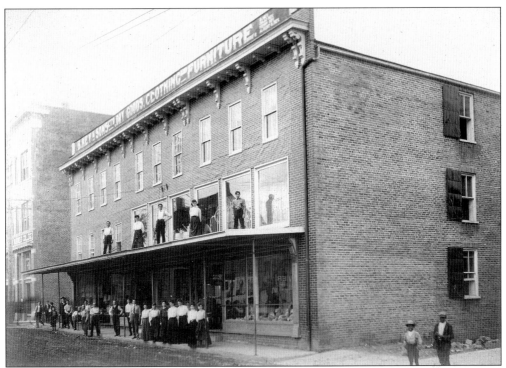

In 1895 B. Ney invited two of his sons to join him in the business and changed the store's name to "B. Ney and Sons." By the time this photograph was taken around 1900, Ney had added large display windows to the building's second floor, and broadened his merchandise to include women's clothing and furniture. (Jeffrey S. Evans Collection.)

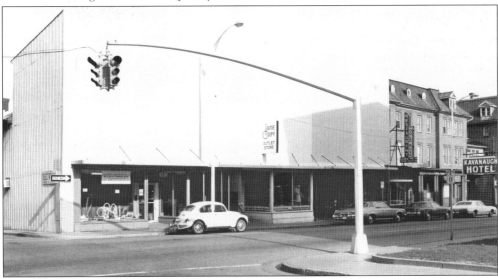

By the mid-1950s B. Ney's store had closed, and a variety of stores filled the space since that time. Displaying an extraordinarily plain façade, in the late 1960s the building was home to the Jane Colby Outlet Store and an Electrolux Vacuum center. The B. Ney store was razed in the late 1970s to make way for Harrisonburg's high-rise office building, Harrison Plaza. (Julius F. Ritchie Collection.)

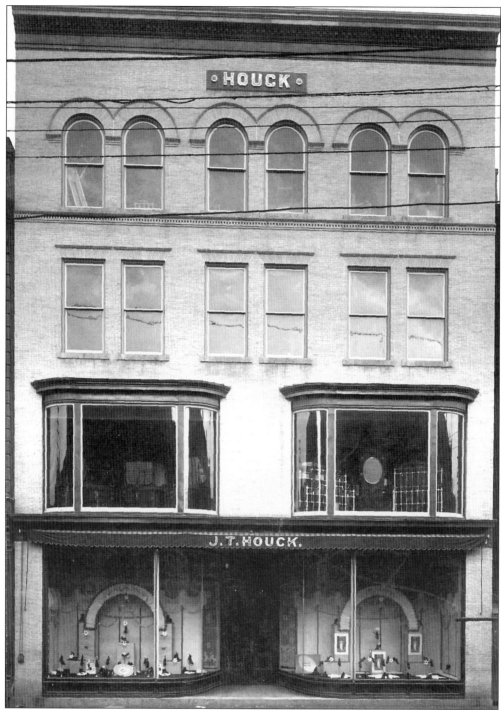

A 1910 advertisement for J.T. Houck's establishment boasted that it carried "Shoes, Carpets, Furniture, Trunks, Harness, Saddles and Leather Goods." This building, constructed by Houck's father, still stands on the west side of South Main Street. Note the shoe styles displayed in the lower windows. (Massanutten Regional Library Collection.)

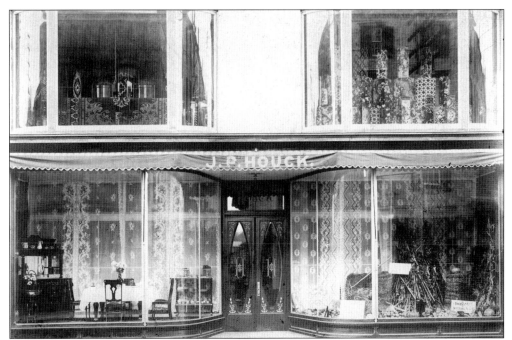

A detailed photograph of the storefront on the opposite page displays the merchandise available when J.P. Houck operated the store. A sign in the right window announces a tournament to be held on November 10th; however, the year is unclear. Father to J.T., the elder Houck came to Harrisonburg from Milnes (now Shenandoah) in Page County around 1878. Along with this mercantile operation, Houck was involved with other business ventures, most notably the large tannery between Water and Bruce Streets. (Massanutten Regional Library Collection.)

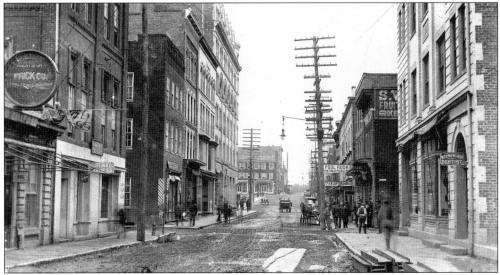

This photograph shows South Main Street from just south of the intersection with Water Street. Taken shortly after 1906 when the Masonic Temple (right) was dedicated, steel I beams suggest that construction was underway for the Keezell Building next door. Down the street, on the left, the second-story bay windows indicate the site of the Houck Building. (Massanutten Regional Library Collection.)

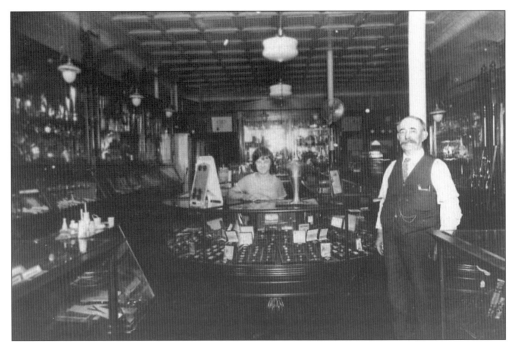

Photographed around 1920, John W. Taliaferro poses in his jewelry store with his assistant Miss Snow. Other jewelers in Harrisonburg around the turn of the 20th century were George O. Conrad, D. Clint Devier, T.E. Grim, Andrew Lewis, and J.W. Vanlear. (Harrisonburg-Rockingham Historical Society Collection.)

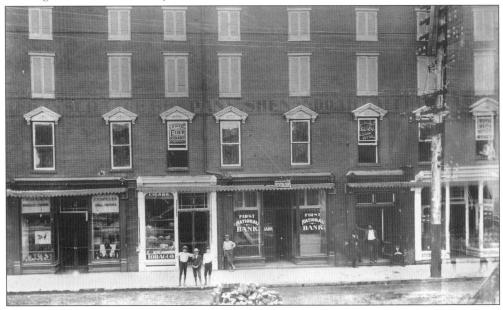

Located just south of Court Square the Spotswood building was a longtime fixture on Main Street in Harrisonburg. Over the years many businesses were housed in the Spotswood's rooms. In this photograph, taken around 1902, J.W. Vanlear's jewelry shop, P.F. Spitzer's book and stationery shop, and the First National Bank were all to be found on the first floor. (Julius F. Ritchie Collection.)

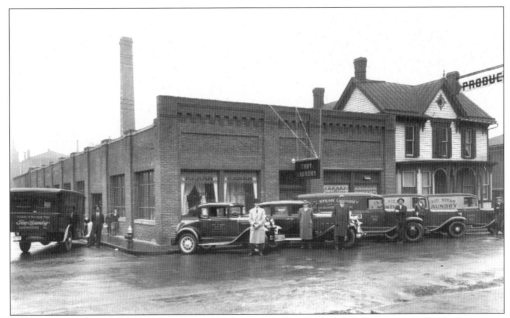

The Troy Steam Laundry opened this building on the corner of Liberty and Wolfe Streets in 1921, although the owners, A.P. Sumption and G.E. Trenary had been in business since 1909. The laundry's original location was on North Main Street. This photograph was taken in the early 1930s. (Harrisonburg-Rockingham Historical Society Collection.)

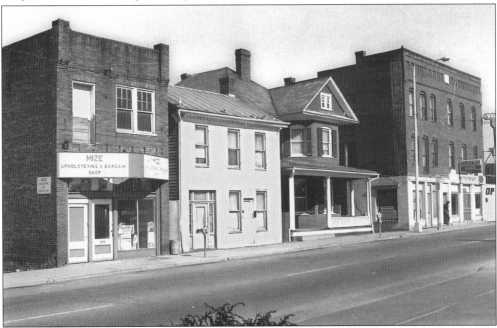

These four structures, located on the west side of North Main Street just before the intersection with Rock Street, demonstrate the blending of commercial and residential buildings along Main Street. From the Valley Hotel on the corner to the storefront that once held Turner's Restaurant, these buildings and others were removed and replaced with the city's Lineweaver Apartments in 1980. (Julius F. Ritchie Collection.)

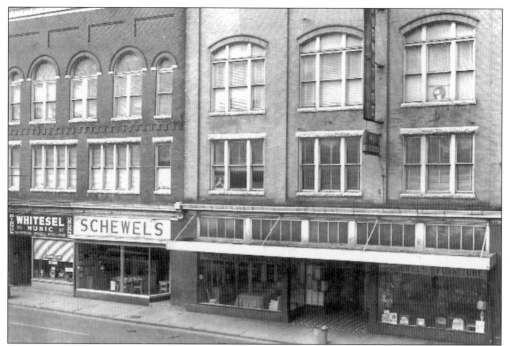

Shown here in 1958, the building on the right was built for the Harrisonburg Realty Company by the J.S. Heatwole Company in 1909. Like other commercial buildings, these two examples on the west side of South Main Street were home to a number of businesses over the years. Schewel's furniture store occupied the space for many years before moving out of downtown Harrisonburg. The buildings were razed in the 1990s and the space currently serves as a parking lot. (Harrisonburg-Rockingham Historical Society Collection.)

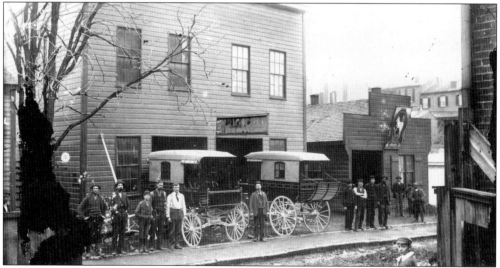

L.J. Golden's carriage works was located on West Water Street when this photo was taken around 1902. He later moved his business to the south side of Court Square, where he continued to make buggies, surreys, and other carriages. The sign with a horse to the right of the carriages in this photograph marks the site of a blacksmith shop. (Julius F. Ritchie Collection.)

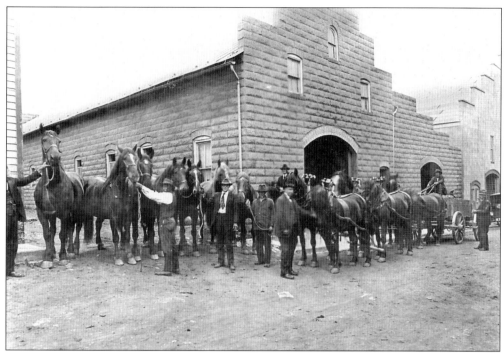

Obviously horses were an important part of life until the 1920s when automobiles became widely available. Several livery stables existed in Harrisonburg and horse-trading was a main event on court days. The Whitmore Brothers, whose stable sat between East Water Street and Newman Avenue, dealt primarily in Percheron draft horses as seen in these two photographs. The pair of photos also documents buildings along Newman Avenue. Above, the stable itself is pictured, while the image below illustrates two dwellings still located on Newman Avenue. (Julius F. Ritchie Collection.)

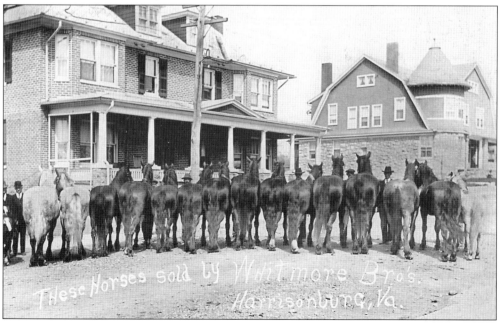

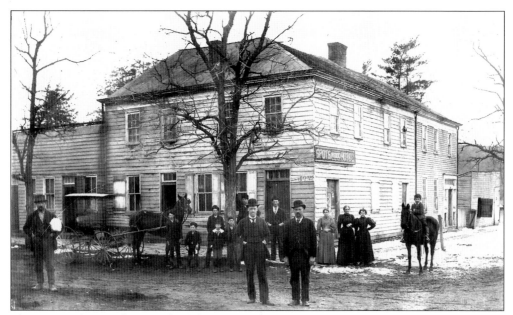

This extremely rare photograph of the Spotswood Hotel documents the building as it stood in the 1880s. An advertisement for the Revere House and Spotswood Hotel in Lake's 1885 atlas reads, "These Hotels are closely adjacent to each other, and are kept as one Hotel, and all under one management. Several large Sample Rooms for Commercial men. E.M. Cartmell, Proprietor." (Greg Evans Collection.)

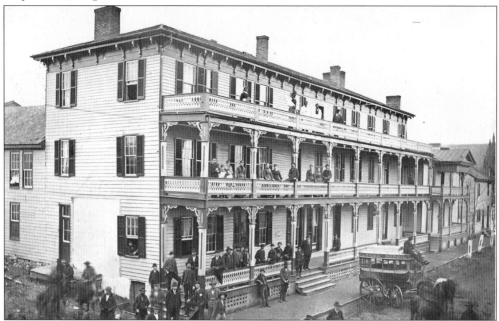

The Revere House stood on South Main Street at the southeast corner of Water Street. This photograph from the early 1870s shows patrons and staff, and provides a glimpse of the rest of the buildings along the street down to the Episcopal church. In 1903 the Masons purchased the property, razing the building in 1905. The Masonic Temple, which still stands on the site, was dedicated in 1906. (Greg Evans Collection.)

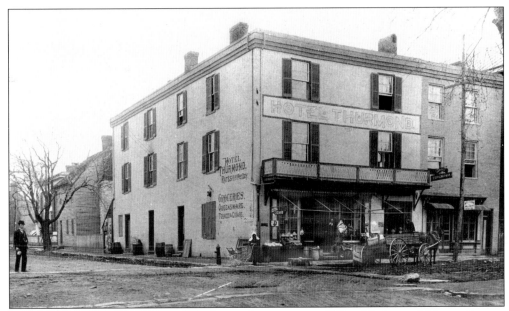

The Hotel Thurmond was located on the northeast corner of West Market and Liberty Streets. The downstairs was a grocery at the time this photograph was taken in the 1890s. Reminiscing about the days of his youth in 1918, longtime *Daily News Record* editor Bill Reilly recalled the market as Billheimer's store in a column in 1953. (Julius F. Ritchie Collection.)

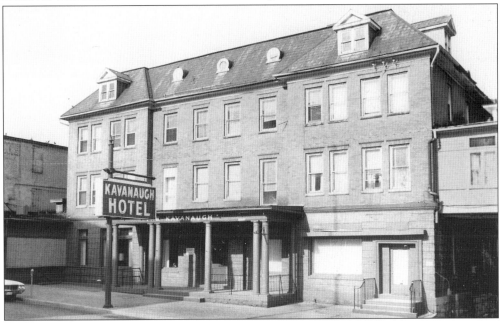

Brothers James and Joseph Kavanaugh opened the Kavanaugh Hotel for business on May 1, 1905. They had built their modern hotel on the site of their father's older building, the Virginia Hotel, which he had owned since 1859. Located on the west side of North Main Street between Elizabeth and Wolfe Streets, the Kavanaugh Hotel initially opened with 53 rooms; however, by 1923 visitors could choose from an additional 64 rooms. The impressive structure was razed in the early 1980s. (Julius F. Ritchie Collection.)

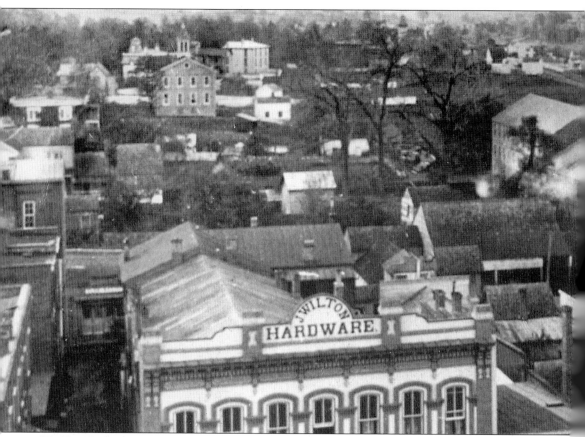

J.P. Houck's massive steam tannery spread over half a city block, reaching from the west bank of Black's Run to Liberty Street between Water and Bruce Streets. In 1885, Houck boasted that his works could tan 10,000 hides per year, a task that required a phenomenal amount of tree bark, which he kept in sheds on the south side of Bruce Street. By using steam engines to power his factory, Houck operated on the vanguard of 19th-century industry and his tannery was one

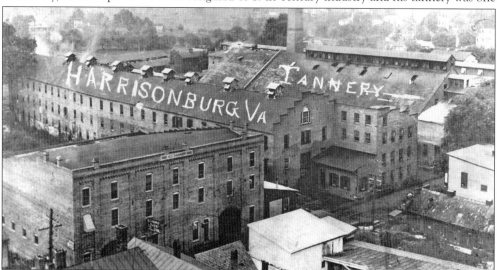

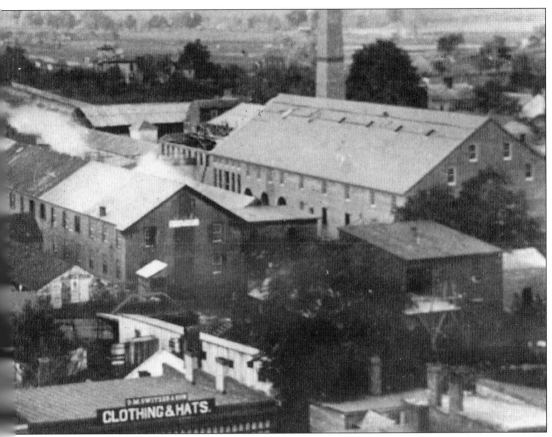

CLOTHING & HATS.

of the largest businesses in Rockingham County. Houck was also a merchant, naturally offering boots, shoes, leather, and harness as well as furniture, trunks, and other household supplies in his store on Main Street. The last of the tannery buildings was razed in the 1960s to add more space to the municipal parking lot. (City of Harrisonburg Collection; Julius F. Ritchie Collection.)

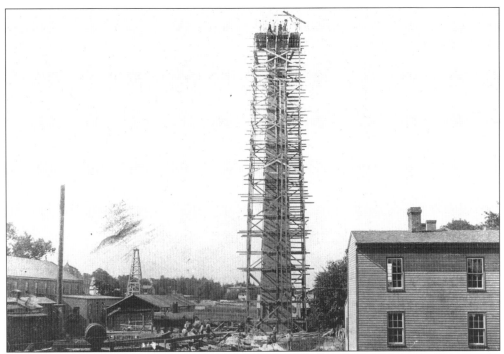

For many years the tallest structure in Harrisonburg, the smokestack at the Houck Tannery was 120 feet high. Houck arrived in Harrisonburg in 1880 and shortly afterwards must have purchased the tannery from J.A. Lowenbach who had begun building a tannery building in 1871. Houck greatly expanded the business. (Julius F. Ritchie Collection.)

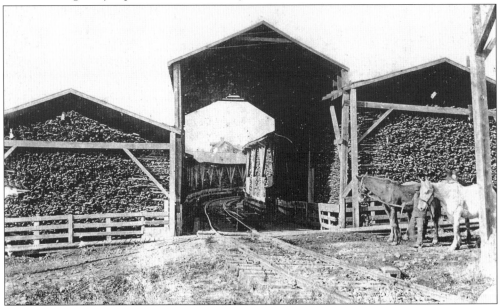

Much of the bark necessary for the hide tanning process was obtained in the mountains west of Harrisonburg. A spur of the railroad ran directly into the sheds pictured here to facilitate the unloading process. Oral history suggests that numerous rattlesnakes that made the ride from the mountains were killed in these sheds. (Julius F. Ritchie Collection.)

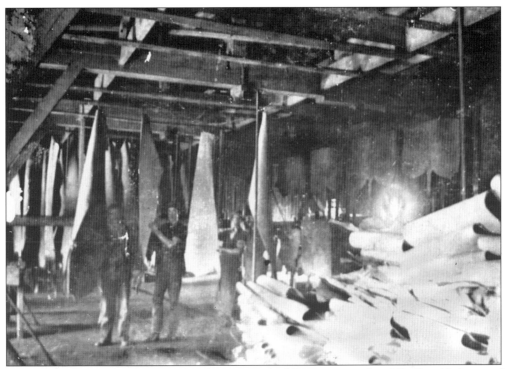

This rare photograph of the inside of a tannery building suggests that J.P. Houck's boast of tanning 10,000 hides a year was perhaps not far from the truth. (Julius F. Ritchie Collection.)

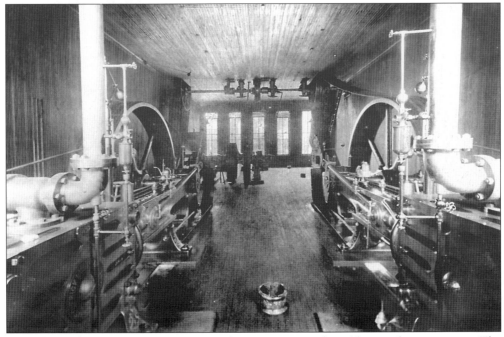

One of Houck's main improvements to the tannery was the addition of steam power. The Corliss Company of Pennsylvania installed the two engines shown here. These engines provided the first electricity in the city in December of 1890. (Julius F. Ritchie Collection.)

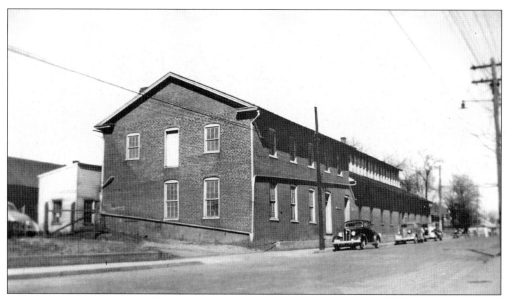

When Philo and Nelson Bradley first opened a foundry in Harrisonburg in 1855 they could not have known that it would still be in business in the early 21st century. Located along what was then the Harrisonburg and Warm Springs Turnpike, the company still maintains an office on Old South High Street. (Harrisonburg-Rockingham Historical Society Collection.)

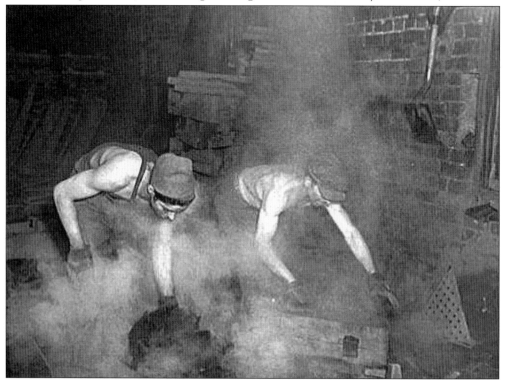

John Vachon, a government-sponsored photographer for the Farm Security Administration, captured these unidentified workers in the Bradley Foundry in 1941. (Library of Congress, Prints & Photographs Division, FSA-OWI Collection.)

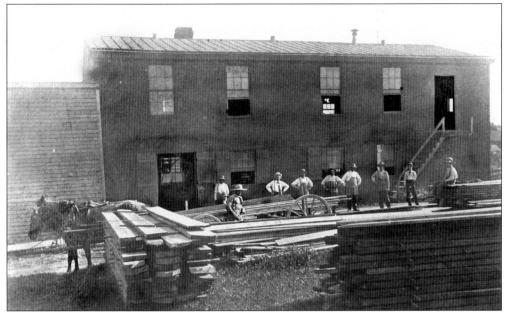

William Bucher and Son was a well-established firm that advertised itself as "Prominent Architects, Contractors, and Builders." William Bucher became established as a contractor in 1870 and his son Russell, a graduate in architecture from the Massachusetts Institute of Technology, joined the company in 1898. Buildings constructed by the firm include the Kavanaugh Hotel, the Catholic church, and the First National Bank Building. The company's lumber mill shown here was located on East Elizabeth Street. (Julius F. Ritchie Collection.)

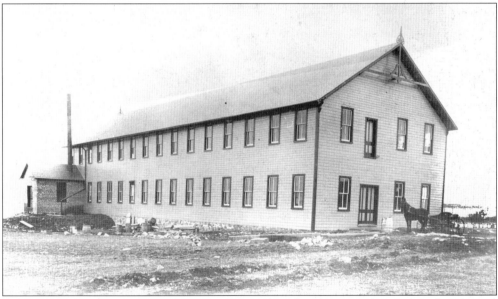

In 1890 a group of Harrisonburg businessmen purchased property on the north end of the city and set out to sell residential and commercial lots. Historically known as a shoe factory, this building may have been one of those constructed along the B&O tracks along with the Rockingham Pottery, the Harrisonburg Steam Pottery, and several other establishments. (Julius F. Ritchie Collection.)

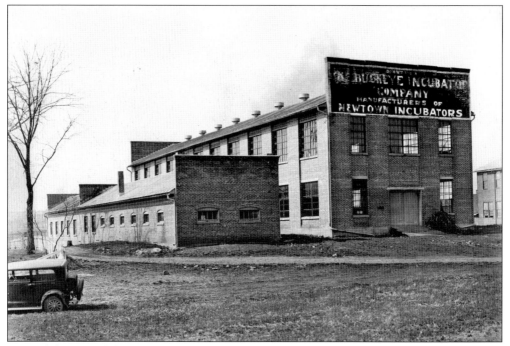

Around the turn of the century J.S. Fravel relocated his Fravel Sash & Door Company from the town of Broadway into these buildings off South Main Street at the end of Warsaw Avenue. Shortly afterward the buildings became the home of Buckeye Incubator Company, manufacturers of the "Newtown Incubator." (City of Harrisonburg Collection.)

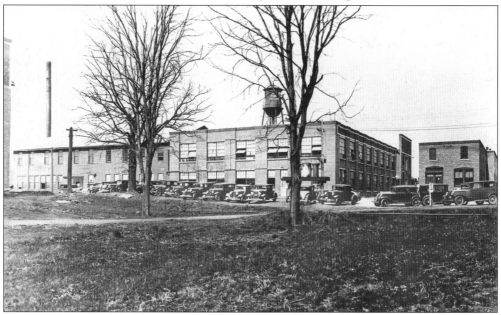

By 1933, the incubator company buildings were occupied by the Daly Shoe Company, which built the additional building shown in this photograph. This site is near the junction of the B&O, Chesapeake and Western railways and was the location of the original C&W station about 1895. (Julius F. Ritchie Collection.)

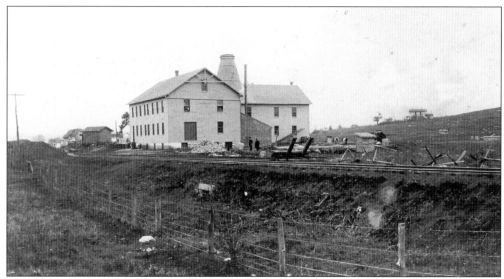

Opening in 1890 along the B&O Railroad north of Harrisonburg, the Rockingham Pottery was part of the planned growth of industry predicted by leading citizens at the time. Managed by William Sherratt of New Jersey, the company went bankrupt by 1893, but later reopened as the Virginia Pottery, which also failed to remain solvent. (Harrisonburg-Rockingham Historical Society Collection.)

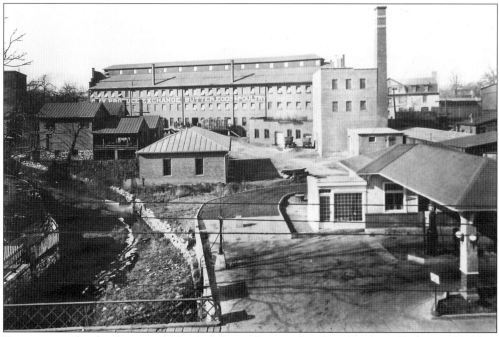

Dominating the landscape of North Liberty Street, the City Produce Exchange building provides a backdrop to this photograph showing Black's Run and one of the many service stations on the north end of town. Formed in 1908 by Hershey Weaver and brothers Emanuel and Gabriel Blosser, the company collected eggs, chickens, and turkeys from area farmers, dressed the birds, and shipped the product to cities on the East Coast. (Julius F. Ritchie Collection.)

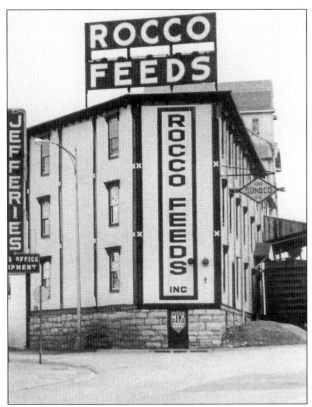

Located at the intersection of Kratzer Avenue and North Main Street, the Rocco Feeds Incorporated building suffered a $65,000 fire in July of 1940. Despite this disaster, the building stood as a landmark of the north end of town until the mid-1980s. (Harrisonburg-Rockingham Historical Society Collection.)

Another 1941 image by FSA photographer John Vachon; his caption reads: "Plant conversion means machine conversion. Here workers at the Harrisonburg, Virginia shop of Beery and Sons are converting a lathe to turn out parts for a war contractor. All the actual work of conversion and the new tools and jigs needed are made in the shop." (Library of Congress, Prints & Photographs Division, FSA-OWI Collection.)

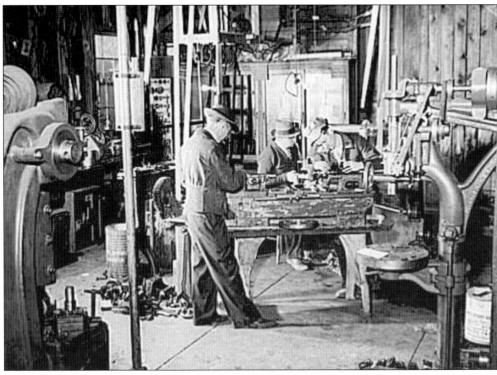

Three

EDUCATION IN THE CITY

Documentary evidence indicates that Harrisonburg's first school was established in 1794 by Methodists who held classes in their early meetinghouse. The number of "scholars" was limited to 40 and under no circumstances were they to wear ruffles or powder their hair. While the city's schools have certainly evolved since this first one, students have undoubtedly been forced to obey the rules regardless of their education in Harrisonburg. In her account of the city in the 1820s Maria Carr recalled attending school on German Street (now Liberty) and studying reading, spelling, writing, arithmetic, grammar, and geography, although she noted: "Ladies of that day never followed any profession . . . they could teach small children their alphabet and work samplers." By mid-century a number of schools had opened in Harrisonburg, and the private funding required for attendance demonstrates the lack of public educational endeavors in the city's first century of existence. By the end of the 1860s, however, Harrisonburg offered ample opportunity for the education of its children and adolescents; in 1870 at least ten schools were advertised in Harrisonburg's newspaper, The Rockingham Register. Although a building was not constructed for educational purposes until 1879, by 1871 the city had adopted Virginia's public educational system. Additionally, realizing the overwhelming need for such a structure, the city fathers ordered the erection of a school for the area's black pupils in 1883.

Along with the public grade schools, private schools continued to thrive in Harrisonburg, particularly for older students. "Normal" schools, or teacher education programs, were common in the city from the 1880s forward, foreshadowing the location of the State Normal and Industrial School for Women in Harrisonburg in 1908. Eventually transformed into James Madison University, the school for higher education was joined by another—the Eastern Mennonite School—in 1917. Now Eastern Mennonite University, in the 1920s the two schools were like bookends on the south and north of Harrisonburg. From its early beginnings in the 18th century to the mid-20th century education has been a central concern in the city.

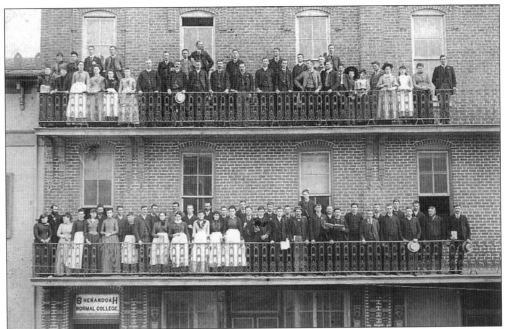

Although short-lived in Harrisonburg, Shenandoah Normal College was relocated here from "down the Valley" at Middletown in 1887. By 1890 the school had moved to Basic City in Augusta County. Located just off Court Square on the south side of West Market Street, here students and faculty pose on the school's balconies. (Harrisonburg-Rockingham Historical Society Collection.)

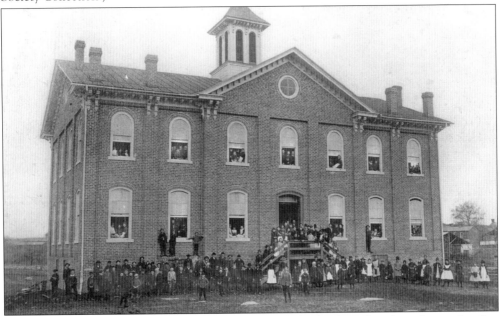

Opened for the school year of 1879–1880, the graded school, or "academy," was the first substantial structure dedicated to the public education of Harrisonburg's youth. The building still stands on South Main, and, along with its 1908 stone addition, houses a number of the city's municipal offices. (Julius F. Ritchie Collection.)

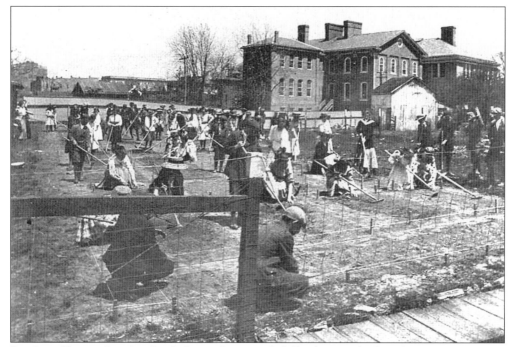

Pupils at Harrisonburg's schools learned practical skills along with their lessons in grammar, reading, and mathematics. In this photograph students at the graded school gain expertise in gardening sometime after 1908. (Harrisonburg-Rockingham Historical Society Collection.)

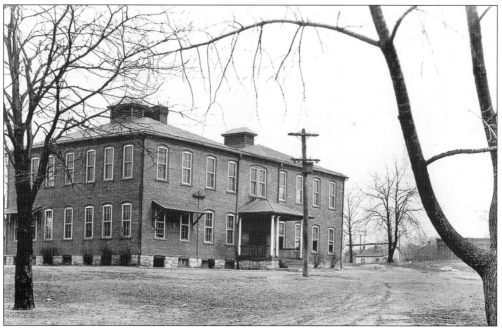

Built in 1883 on the northern edge of the city, the Effinger Street School served Harrisonburg's black community until 1939. Originally a four-room school, in 1910 an identical building was added to the west end of the existing structure, giving the building the appearance seen in this photograph. (City of Harrisonburg Collection.)

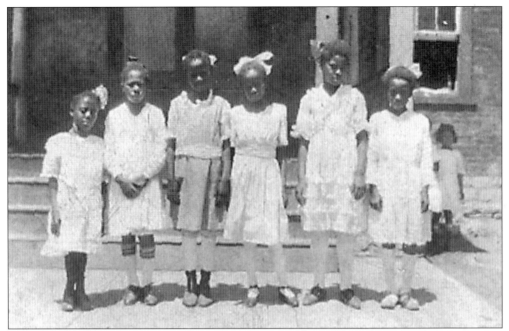

Shown in front of the Effinger Street School, six young girls pose for the camera, while another peeks out from the shadows. A compulsory school attendance law was enacted in the city in 1911, requiring all children to attend public schools. (Jennifer Vickers Collection.)

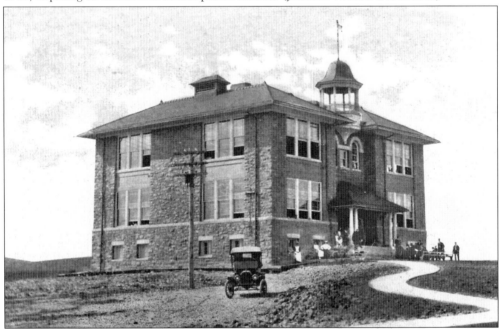

In order to meet the demands of the growing population of school-aged children now required to attend school, in 1910–1911 the city erected a new school on land donated by A.G. Waterman. Located along the Mt. Clinton Pike (Chicago Avenue) on the northwest edge of Harrisonburg, Waterman school required a ten-room addition in 1925. (Harrisonburg-Rockingham Historical Society Collection.)

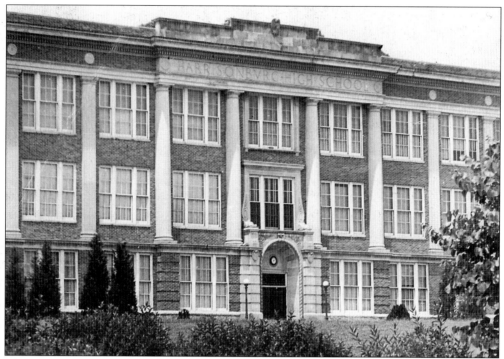

The 1920s witnessed an impressive commitment to public education in Harrisonburg. Along with additions to Waterman school, the city invested $225,000 in a new high school in 1928, building the impressive structure on the site of the community's fair grounds. By 1934 the edifice required an addition. (Julius F. Ritchie Collection.)

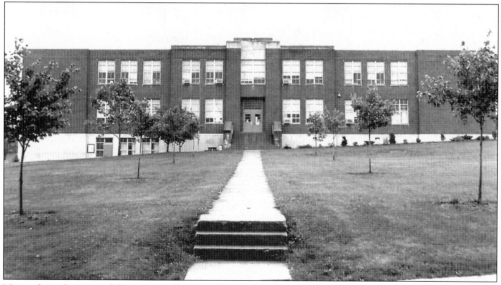

Named in honor of longtime Harrisonburg educator Lucy F. Simms, this school building replaced the Effinger Street School in 1938. The building served as the primary educational center for blacks in Harrisonburg and Rockingham County until schools were integrated in 1964. Simms School is located only a few hundred yards from the spot where its namesake was born a slave in 1855. (Harrisonburg-Rockingham Historical Society Collection.)

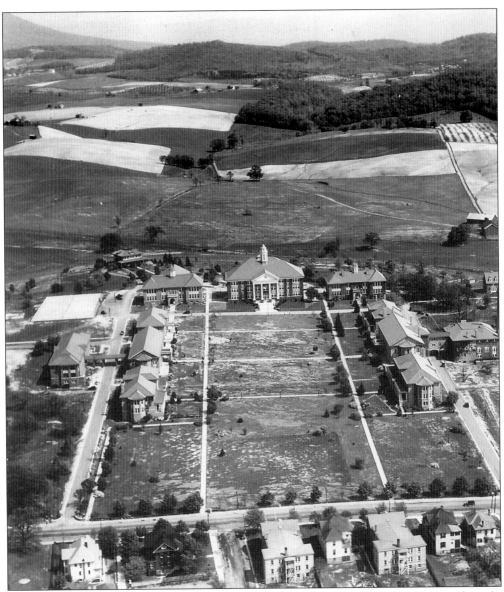

By the early 1930s when this photo was taken, the State Teachers College at Harrisonburg (it became Madison College in 1938) was already growing dramatically. This view of their symmetrical campus illustrates the physical presence it imposed on the local landscape. Originally built on the A.M. Newman farm, this image shows signs of the school's future encroachment on the rolling countryside around it. (James Madison University, Carrier Library, Special Collections.)

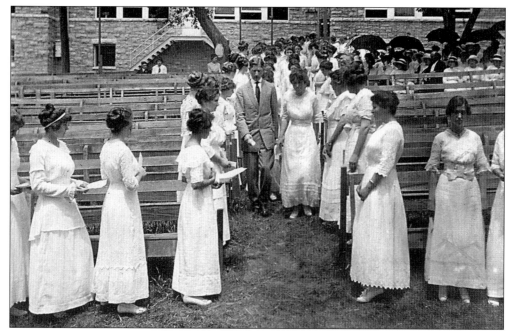

Taken in the outdoor theater located behind the Science Hall (Maury Hall), this 1914 photograph offers a glimpse of the Class Day exercise held annually as part of the five-day commencement program. Here school president Julian Burruss is escorted to his seat by senior students. In the days before an auditorium was built the outdoor seating provided a site for numerous ceremonies and dramatic productions. (James Madison University, Carrier Library, Special Collections.)

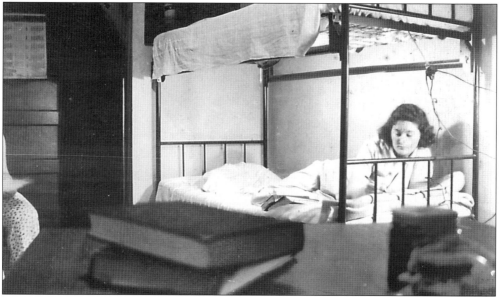

Relaxing in Room 24 of Madison College's Spotswood Hall, an unidentified student appears interested in her reading. Madison Memorial Library had not yet been built when this photo was taken and one's room may have been the quietest place to study. This artistic shot provides a unique glimpse of dorm life in the 1920s. (Private Collection.)

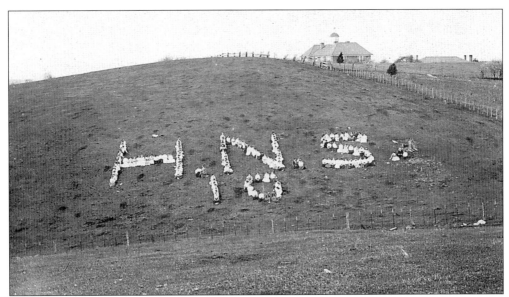

Students at both the Harrisonburg Normal School and the Eastern Mennonite School found an interesting way to pose for class pictures. The Normal School was in its second year of existence when the photo above was taken. The roof and cupola of Maury Hall are visible in the background. (James Madison University, Carrier Library, Special Collections; Eastern Mennonite University, Menno Simons Archives Collection.)

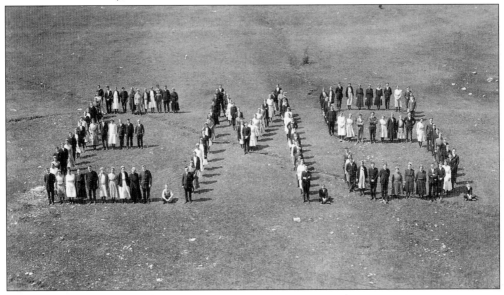

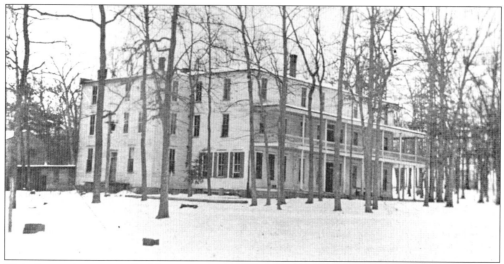

This large three-story building was originally a hotel managed by A.P. Funkhouser at Assembly Park in the Park View section just north of Harrisonburg. Dating from the 1860s, the park was home to many functions, including races, agricultural fairs, and lectures. In 1916 the building was purchased by a group of Mennonites, and served as the initial home to what has become Eastern Mennonite University. (Eastern Mennonite University, Menno Simons Archives Collection.)

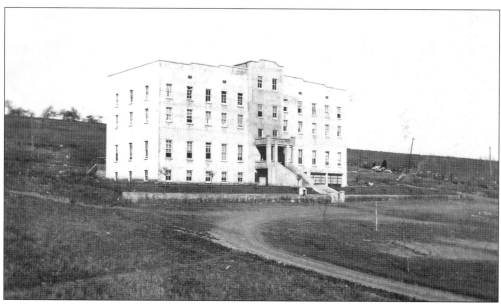

Built in 1923 on a gently rising hill just west of Assembly Park, Eastern Mennonite School's first new building housed students, classrooms, and academic offices. As enrollment increased brick wings flanked the building, which burned in 1984. (Eastern Mennonite University, Menno Simons Archives Collection.)

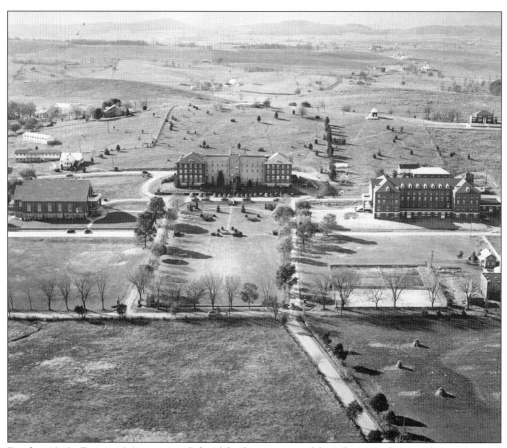

By the 1940s Eastern Mennonite School had grown steadily. This aerial view shows the two wings of the Administration Building, the chapel at left, and Northlawn, the residence hall, on the right. The panoramic quality of the photo illustrates the school's location on the edge of the city. Much of the countryside visible to the west remains rural today. (Eastern Mennonite University, Menno Simons Archives Collection.)

Four

MAKING A HOME

Harrisonburg's residential neighborhoods began, like the city itself, on and around Court Square. While founding father Thomas Harrison's stone house remains extant, nearly all of the earliest structures of log and stone have been razed over the years as the city's center commercialized and residents demonstrated their desire for the new and fashionable. Throughout the 19th century residences were blended with commercial buildings, while in some cases a house served as both home and business. The earliest images of Court Square, for instance, show the stone Waterman House and the brick Kenney House intermingled with stores, hotels, and government buildings. By the last quarter of the century, however, large houses began to appear on the edges of the commercial district, with East Market Street and South Main Street particularly exhibiting houses of the most current styles.

The images of houses and neighborhoods presented here offer a glimpse at the changing face of the domestic landscape of Harrisonburg. The earliest dwellings, such as Harrison's, display the blending of ethnic traditions that were already taking place in the Shenandoah Valley by the late 18th century. Harrison, of English descent, built his story-and-a-half house of stone, a building material traditionally used by German and Swiss immigrants, while the form of the house remained true to his English ancestry. Oral and written history tells us that many of the city's earliest houses were constructed with horizontal logs and later dressed up with clapboards. This again implies that a central European influence had pervaded the constructed landscape of the Valley. Few houses were built this way after the mid-19th century as framed houses erected with milled lumber became the common, and cheaper, type of dwelling. Variations of fashionable Victorian houses began to dot the city's landscape in the 1870s, however, reflecting the success of Harrisonburg's business district. Less expensive housing also appeared as the city's population grew. Together they formed an eclectic pattern of architecture that remains evident in the early 21st century.

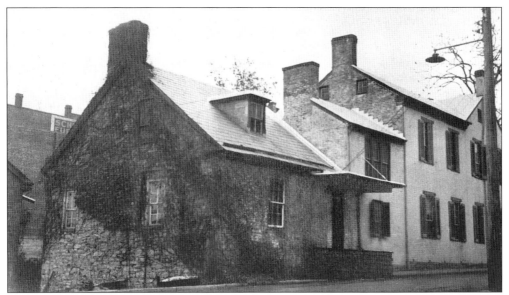

While Thomas Harrison occupied the site of Harrisonburg as early as 1737, he may not have built this stone story-and-a-half house until around 1750. Built over one of two springs in the vicinity, the house and its situation are typical of those built in the Shenandoah Valley in the mid-18th century. James Hall added a Federal-style brick house onto the side of the structure in the 1820s. The brick portion was later altered to make way for a commercial building. (Private Collection.)

Located along the Warm Springs Turnpike on what is now the south end of Harrisonburg, this limestone house was built in 1793 by Lewis and Barbara Bibler. The Biblers, like many of their neighbors in the Harrisonburg area, migrated up the Shenandoah Valley from Pennsylvania. As with Harrison's house, this sturdy home was built over a spring. (Harrisonburg-Rockingham Historical Society Collection.)

Believed to be the residence of Reuben Harrison, a son of Thomas Harrison, this house is indicative of a number of 18th-century stone dwellings built in Harrisonburg. The younger Harrison was taxed eight shillings for this property, one of seven houses classified for tax purposes as "first class" in 1798, located on the corner of Liberty and West Elizabeth Streets. Photographed in 1933 for the Historic American Buildings Survey, the house was razed in 1940. (Library of Congress, Prints and Photographs Division, Historic American Buildings Survey Collection.)

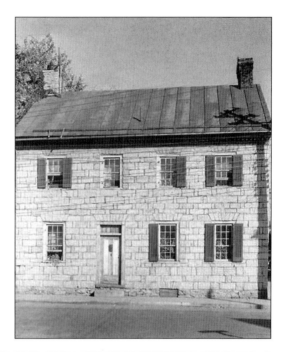

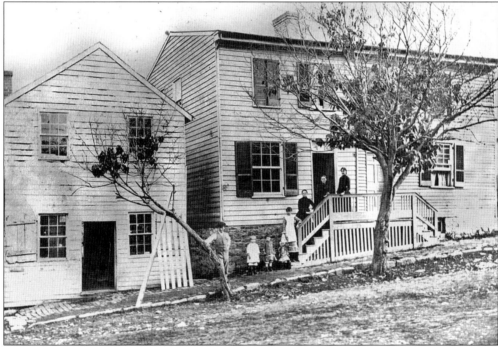

Located on the east side of Liberty Street between Water and West Market Streets, this large two-story house was constructed of logs. Pictured here is the family of Oliver and Margaret Helphenstein. Helphenstein was a tinsmith, but the property also later served as Jacob Houck's hat shop. Eventually home to Ed Friddle's bakery, in the 1950s both the house and the tin shop next door gave way to a parking lot for Denton's furniture. (Harrisonburg-Rockingham Historical Society Collection.)

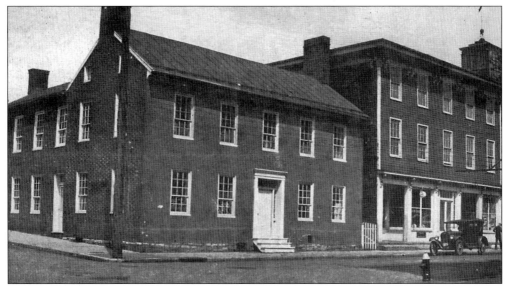

Long known as the Morrison House, this impressive Federal-style brick dwelling was most likely built by Joseph Thornton in the early 1820s. John C. Morrison and his wife Henrietta took up residence in the house in 1858 and located their carriage shop next door. A landmark on the corner of Liberty and West Market Streets, the house was torn down in 1982, after preservation-minded citizens failed in their effort to save it. (Harrisonburg-Rockingham Historical Society Collection.)

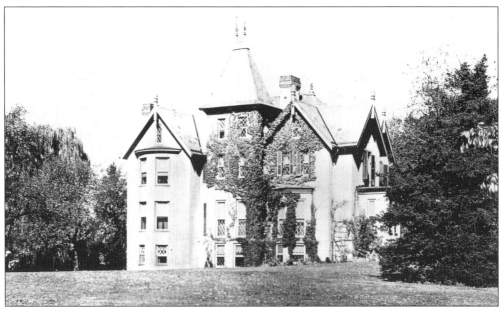

Displaying the bay windows, gable trim, and diamond shape sashes characteristic of the Gothic Revival, this grand house stood at the convergence of South Liberty and South Main Streets. Built by Harrisonburg attorney John Green Smith in the late 1850s and later owned by the well-known congressman and attorney John T. Harris Jr., the imposing house was long a landmark on the southern end of the city. In the 1950s the structure was removed to accommodate the present Harrisonburg Baptist Church building. (Julius F. Ritchie Collection.)

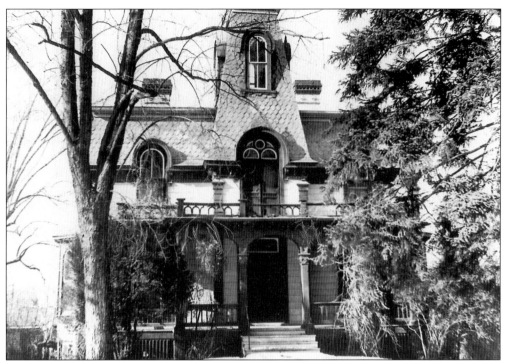

Built by Charles A. Sprinkle around 1865, this fine example of the Second Empire style demonstrates Harrisonburg's fashion consciousness shortly after the Civil War. Sprinkle, a captain in the Confederate Army, returned to his hometown, served as a depot agent for the B&O Railroad, and eventually opened a farm machinery business. Long out of style, the house, located on the west side of South Main Street, was demolished in 1963 to make room for a Sears catalog outlet. (Julius F. Ritchie Collection.)

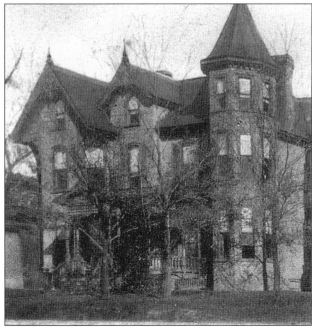

Known for many years as the Gilmer property, this 1874 Victorian-style house was purchased by Dr. T.O. Jones in 1884. In 1929 the house was sold to the Professional Building Association. Once next door to the Episcopal church, the Massanutten Regional Library currently occupies the site of both buildings. (Julius F. Ritchie Collection.)

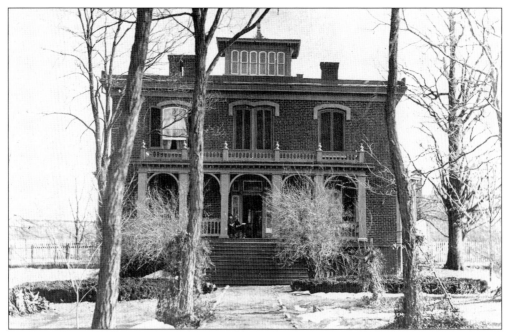

Reflecting the movement of residential housing out of the downtown business district, this house is located on South Main Street at the corner of Paul Street. Probably built by Harrisonburg attorney Warren S. Lurty around 1875, the house is indicative of the Italianate-style popular from the 1840s to 1880. Since 1928 the house has been home to the Benevolent & Protective Order of Elks. (Julius F. Ritchie Collection.)

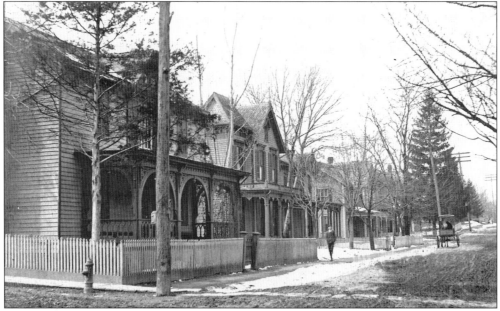

Shown on a winter's day, these houses in Loewenbach's Addition on the south side of West Market Street illustrate the common Victorian frame houses that were springing up in Harrisonburg from the early 1880s onward. Neither elaborate nor plain, these attractive homes lined West Market and other streets. (Massanutten Regional Library Collection.)

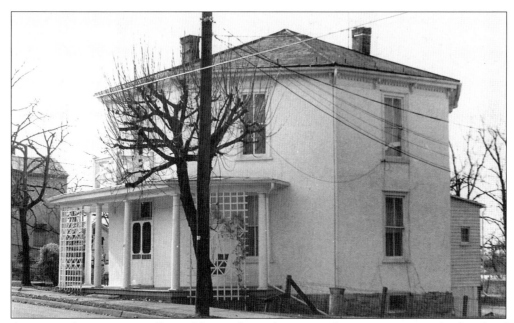

A rarity in the nation, as well as in Harrisonburg, the octagon house type was popular for a brief period from 1850 to 1870. Oddly, J. Wesley Miller built this example in the mid-1880s, some time after the style's heyday. Although touted as superior to square houses for ventilation and letting in natural light, the style never caught on. Harrisonburg's lone example continues to stand on South Liberty Street. (Julius F. Ritchie Collection.)

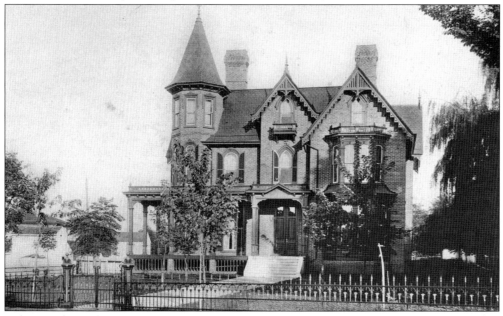

Joshua Wilton's house on South Main Street is clearly one of Harrisonburg's outstanding examples of Victorian architecture. Built around 1890 by the well-known hardware store owner and one-time bank president, the house has lived through the years as a family dwelling, a college fraternity house, and a restaurant and inn. It continues to stand as a testimony to the high life once lived on South Main. (Julius F. Ritchie Collection.)

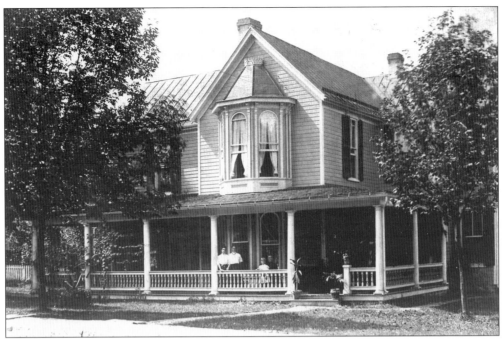

Built adjacent to the Sprinkle House and across the street from the Joshua Wilson House in the 1890s, this attractive example of a vernacular Victorian style demonstrates the adaptation of a simple frame house to one with enough flair to fit in on the fashionable South Main Street. Home to attorney W.L. Yancey and his family, the house and grounds were leveled for a parking lot in 1966. (Julius F. Ritchie Collection.)

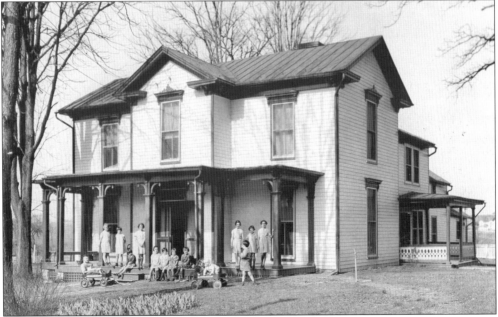

This typical turn-of-the-century frame house was located on Harrison Street just west of South Main Street. The city maintained the house as a home for orphans in the 1920s and 1930s. (City of Harrisonburg Collection.)

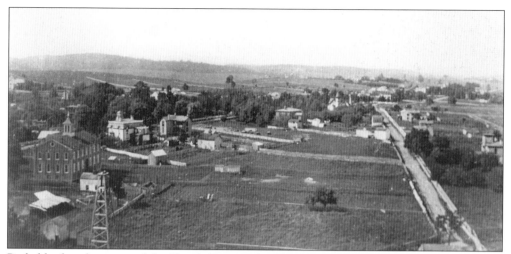

Probably shot from one of the Houck Tannery buildings in the mid-1880s, this image looking south along Liberty Street illustrates the sparse housing along that road. The Harrisonburg graded school (today's Municipal Building) and the C.A. Sprinkle house are visible along the tree-lined Main Street on the left. (City of Harrisonburg Collection.)

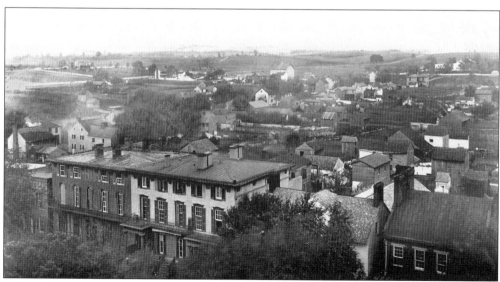

Looking northwest from the courthouse over the Warren Hotel, this view illustrates the density of buildings surrounding the downtown area. In the 1890s, when this photograph was taken, the area west of Liberty Street remained farmland, a situation that would not last for long. (Julius F. Ritchie Collection.)

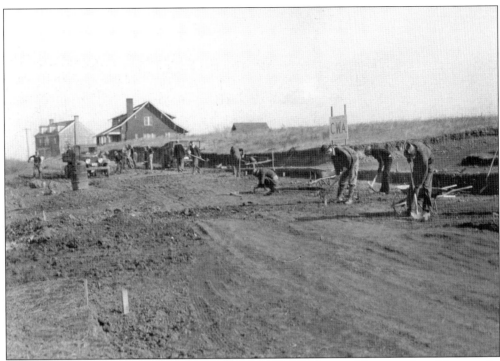

Ott Street's location atop the hill east of downtown makes it one of the most desirable spots for a home in Harrisonburg. Views over the city and to the mountains in the west have long provided city residents with stunning panoramic scenes. Above, workers grade the street near its intersection with Paul Street, making way for further development of the location. The intersection of Ott and Campbell Streets proved to be so steep that a new idea was proposed. Below, stonemasons construct the wall that continues to stand at the eastern terminus of Campbell Street. These improvements were made in 1934. (City of Harrisonburg Collection.)

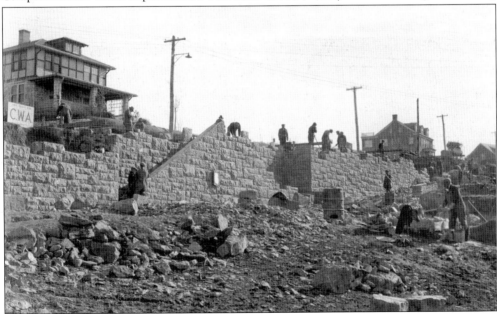

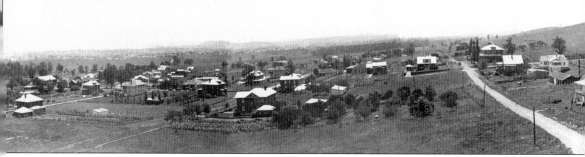

As Eastern Mennonite School expanded, so, too, did the community surrounding it. Known as Park View because of its proximity to Assembly Park, this Harrisonburg "suburb" was originally a small group of houses along the Mount Clinton Turnpike. Looking south, this 1935 photo, with the "Pike" coming down the hill at right, illustrates the growth of the area after the opening of the school. (Eastern Mennonite University, Menno Simons Archives Collection.)

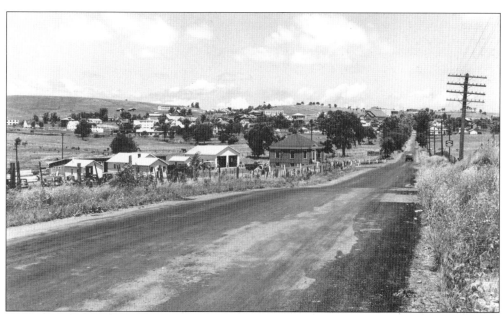

Known in 1885 as the Harrisonburg & Franklin Turnpike, later the Mount Clinton Pike, and today Chicago Avenue, this stretch of road connects Harrisonburg to Park View. This view, taken in 1942 just south of the intersection with Waterman Drive, further illustrates the growth of Harrisonburg's "suburb" in the 1930s. Eastern Mennonite College's chapel is visible in the photo's background. (Eastern Mennonite University, Menno Simons Archives Collection.)

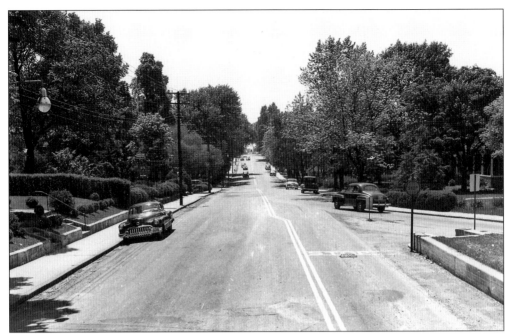

This 1950s view down South Main Street from the intersection with Liberty Street shows an inviting tree-lined avenue. "Improvements" through the years have turned South Main from this point onward into a bustling four-lane thoroughfare. (Julius F. Ritchie Collection.)

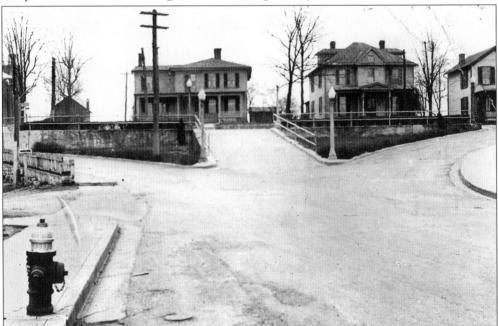

The intersection of West Bruce and South High Streets was another interesting junction that many city residents recall. "Improvement" of High Street to a four-lane highway in the early 1970s provided municipal crews with an opportunity to develop a less cumbersome arrangement, as the residential South High Street shown here became known as "Old South High." (Julius F. Ritchie Collection.)

Five

THE FLOW OF EVERYDAY LIFE

Throughout the city's history, the citizens of Harrisonburg have experienced the range of community life common to many throughout the United States. The photographs in this section offer a look at the character of the people of the city—a glimpse at how they lived, what they believed was important, and how they spent their spare time. The images here reflect the responsible nature of the city's leaders as they pulled together to form competitive fire companies, provide utilities to their constituents, and guide the men of the community in a time of war. These photos show the faces of the people who participated in the flow of everyday life in Harrisonburg, along with the buildings and spaces they inhabited.

The photographs also reveal the changes that have flowed over Harrisonburg as the years have progressed. In 1902, J.L. Baugher owned the first automobile in Harrisonburg; by 2002, many historic buildings, including some pictured here, had been razed and replaced with lots for parking the many automobiles that entered the city daily. When too much traffic on Main Street—U.S. Highway 11—altered life downtown a bypass was created that required thirty acres of farmland east of the city for its novel cloverleaf intersection. The photographs in this section tell a representative story of the flow of Harrisonburg. They tell the story of its residents and the choices they made about their lives and the city and world in which they lived. They tell the story of their celebrations and their tragedies. They tell the story of everyday life in Harrisonburg.

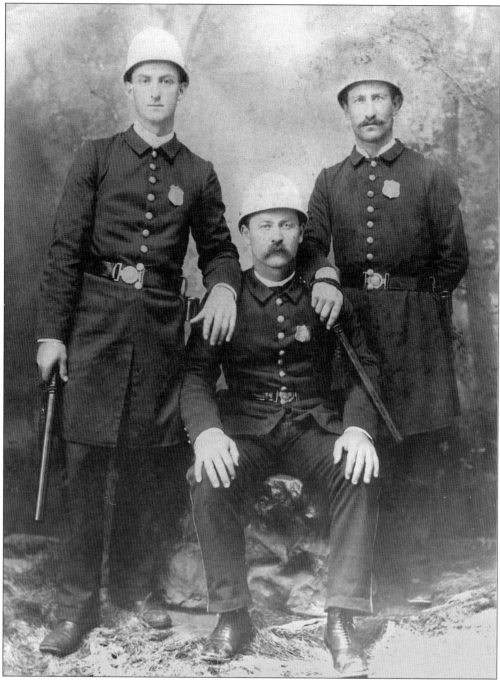

Harrisonburg expanded rapidly in the 19th century and by the early 1890s the city required a three-man police force. Pictured here from left to right are, Joseph Kavanaugh, Chief Jehu Long (seated), and William Fultz. (Greg Evans Collection.)

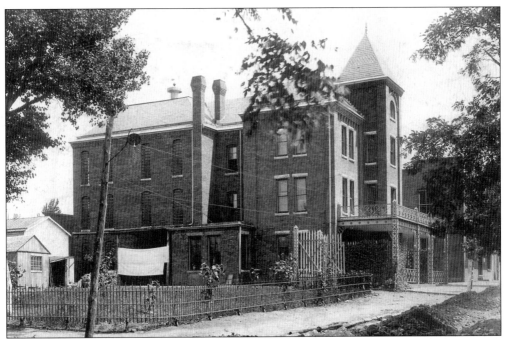

Perhaps foreseeing the growth of the judicial system in Rockingham County, this new jail on Graham Street was opened in 1895, the year before the present Courthouse was built. Remodeled in 1933–1934, the building was demolished in the early 1990s; the space now provides parking for Court Square. (Harrisonburg-Rockingham Historical Society Collection.)

After most of the Houck Tannery buildings were razed, the City of Harrisonburg purchased the entire lot and one remaining building in 1939 for $30,000. Shortly afterward the police department moved from the Municipal Building on Court Square to the north end of the remaining structure, which ran parallel to Liberty Street. (Julius F. Ritchie Collection.)

City leaders encouraged leadership and civic responsibility in Harrisonburg's children beginning at an early age. In this photograph chief of police Julius Ritchie (right) and an unidentified officer pose with the crossing guard of a local elementary school. (Julius F. Ritchie Collection.)

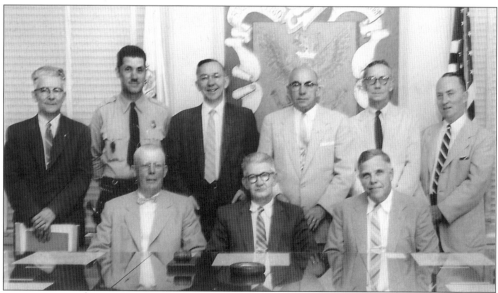

Members of the influential Harrisonburg City Council and other officials posed for this photo around 1960. Pictured left to right are, (seated) Vice-Mayor Dan L. Logan, Mayor Frank C. Switzer, Councilman Clarence W. Ewing; (back row) Deputy Clerk Allen M. Birchard, Chief of Police Julius F. Ritchie, City Attorney Lawrence H. Hoover, City Manager Arthur L. Dow, Councilman Walter M. Zirkle, Councilman George W. Taliaferro. (Julius F. Ritchie Collection.)

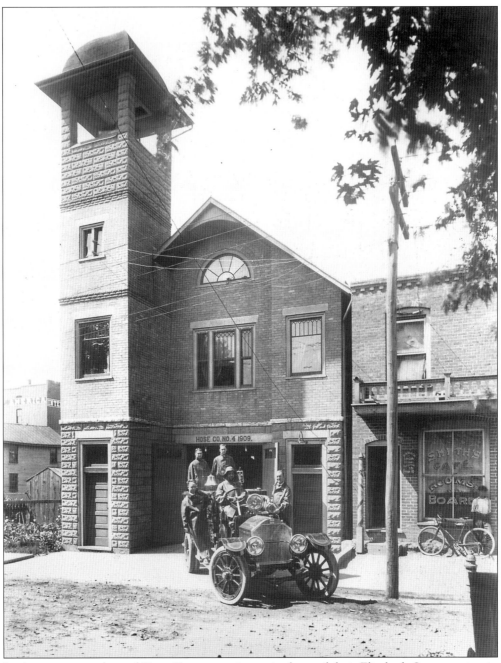

In this image members of Hose Company #4 pose in front of their Elizabeth Street station in the early 1920s. The truck on which they are proudly perched was purchased from a Winchester fire department. The fire station is no longer standing. (Harrisonburg-Rockingham Historical Society Collection.)

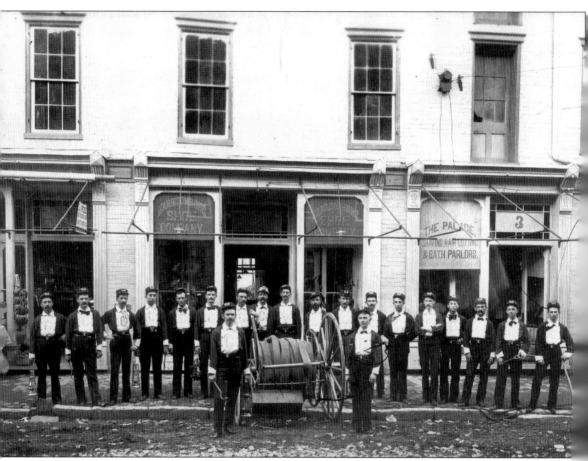

Posing with their reel in front of South Main's Spotswood building, the Central Hose Company appears ready for action. During a July 4th competition in 1893, the team set a local record for racing 300 feet with their reel, coupling their hose to a hydrant, and spraying water—the time was 28 seconds. Harrisonburg's four hose companies were each housed in a different part of the growing city and a sharp sense of competition existed over who would reach a fire first. (Harrisonburg-Rockingham Historical Society Collection.)

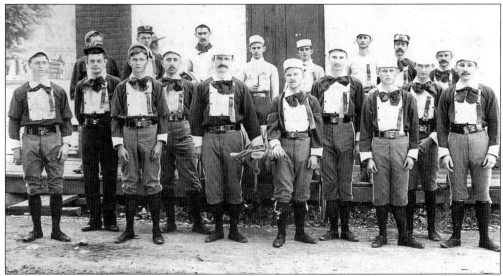

Housed in the council chambers building on Court Square, Central Hose Company was also known as Hose Company #2. Members of the company's running team were, left to right, (front row) P.W. Effinger, J.S. M'Quay, W.E. Compton, and C.S. Sanford; (middle row) J.F. Lewis, Stuart Beery, I.P. Fletcher, I.S. McNeil, and L.H. Bowman; (back row) G.N. Conrad, W.H. Rohr, J.T. Houck, J. Barton Effinger, G.H. Effinger, M.L. Saum, W.L. Magalis, T.A. Long, and G.H. Priloh. (Massanutten Regional Library Collection.)

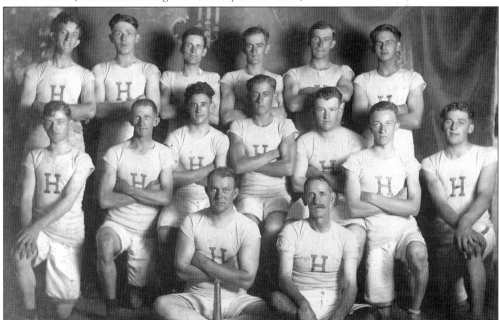

Hose Company #4 was Harrisonburg's first hose team to enter State Firemen's convention contests in 1893; over the years the other reel racing teams also entered the statewide challenges. Here #4's team poses proudly after a successful competition in 1915. Pictured from left to right are (seated) E. Lamb and Harvey Bassford (foreman); (kneeling) I. Ford, D. Bassford, M. Loewner, B. Noll, B. Stroll, J. Kelly, and L. Berry; (standing) B. Bowman, R. Miller, E. Long, J. Noll, B. Lamb, and M. Crawford. (Jeffrey S. Evans Collection.)

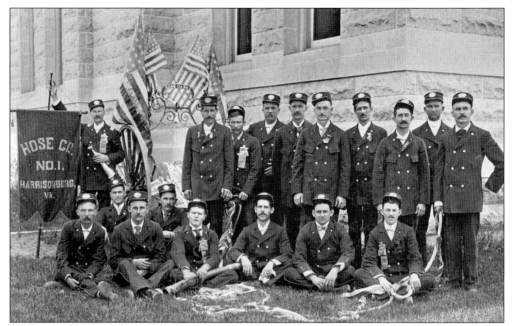

The 18 members of Hose Company #1 pose by the newly opened courthouse in the late 1890s. One of four hose companies formed around 1888, #1 housed its reel and hose next to the Virginia Hotel (later Kavanaugh) on North Main Street. (Harrisonburg-Rockingham Historical Society Collection.)

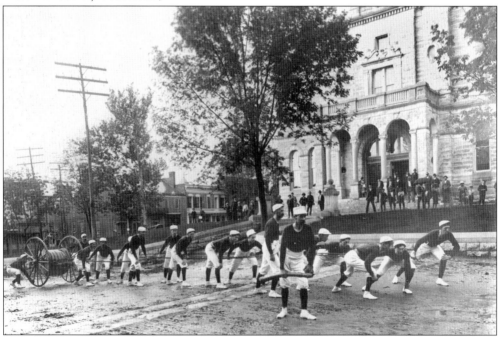

Demonstrating their starting form, an unidentified Harrisonburg hose company poises in readiness. Hose company's reel race teams practiced for weeks before local and state competitions where they were judged not only on speed, but also on appearance. (Julius F. Ritchie Collection.)

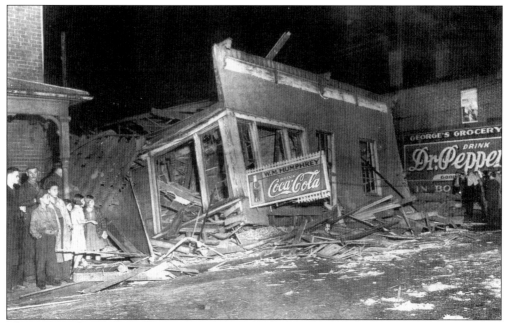

The 1938 explosion of W.M. Humphrey's former restaurant and Sam Stover's pool room on the southwest corner of North Main and Gay Streets killed one and injured 15 others. This disaster foreshadowed the even more devastating blast of the Masters Building in July of 1947, in which 11 lost their lives and 18 more were injured. (Julius F. Ritchie Collection.)

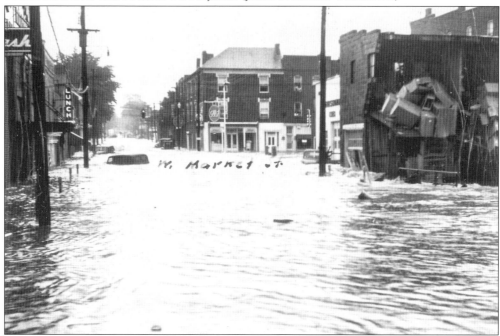

On October 15, 1942, Black's Run flooded Liberty Street around West Market Street, causing considerable damage to property. This view surveys the scene from Water Street looking north toward West Market. A portion of Denton's Furniture warehouse collapsed in the surging water. (Julius F. Ritchie Collection.)

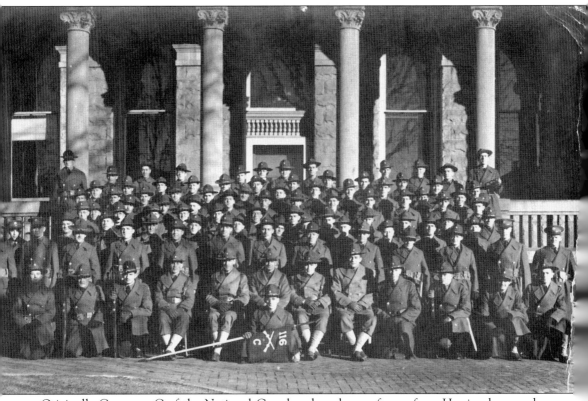

Originally Company C of the National Guard and made up of men from Harrisonburg and Rockingham County, the group became Company C of the 116th Infantry of the United States Army when it was inducted by order of President Franklin Roosevelt on February 3, 1941. After spending a year in training at Fort Meade in Maryland, the company did see action in Europe during World War II. Along with numerous other assignments, the company was part of the invasion at Normandy on D Day. (Harrisonburg-Rockingham Historical Society Collection)

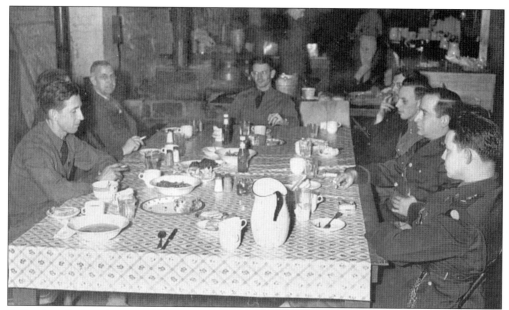

Following their induction, Company C encamped at the armory in the old tannery building on West Water Street. Members of the company trained, ate, and slept there. This photograph shows a group gathered for supper in the armory. The diners are, from left to right, Bob Hering, Ward Swank, Frank Switzer, J.R. "Polly" Lineweaver (*Daily News Record* reporter), William Bryan, Allen Hasenfluck, and Joe Bennington. (Harrisonburg-Rockingham Historical Society Collection.)

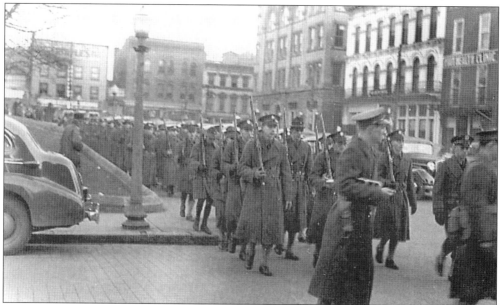

Writing in a 1942 special war edition, A *Daily News Record* reporter recounted the two weeks spent by Company C members awaiting orders at the armory. He recalled that "The second afternoon Company C stood retreat at 5:15 pm on Court Square with a large crowd filling the square to watch the impressive ceremony." (Harrisonburg-Rockingham Historical Society Collection.)

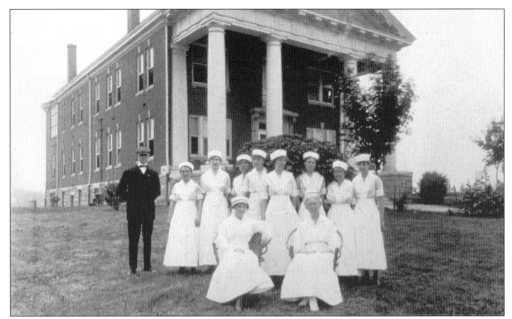

Rockingham Memorial Hospital was formally opened on October 1, 1912, in the building shown here. Made possible by a 1908 bequest of over $20,000 by Harrisonburg resident William G. Leake, the hospital filled a need in this part of the Shenandoah Valley. The original building was razed for expansion in the 1990s, although the façade was saved and attached to the new building. (Harrisonburg-Rockingham Historical Society Collection.)

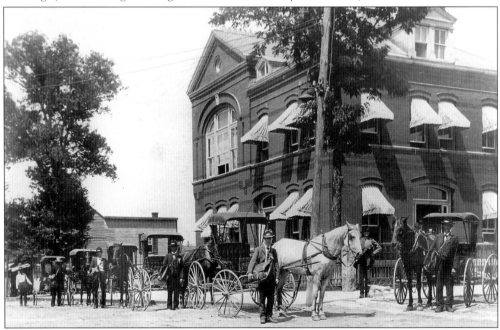

The first federal building erected in the city, this combination courthouse and post office was built around 1885. Located on the northeast corner of Main and Elizabeth Streets the building stood until it was razed and the present building built in 1939. Still standing and in use, the current building was opened in 1940. (Julius F. Ritchie Collection.)

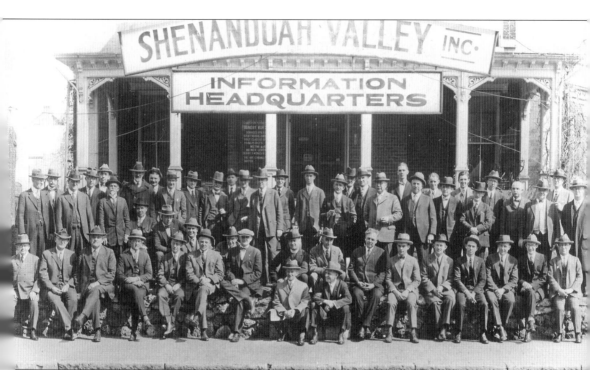

An organization aimed at bringing tourists to the region, Shenandoah Valley Incorporated was founded in January 1924, during a meeting held at the New Virginia Theater in Harrisonburg. Posed in front of their headquarters, the Dr. John Neff house at South Main Street and Newman Avenue, those pictured are, left to right, (front row) Glen Alexander, Dr. W.T. Lineweaver, A.P. Sumption, Herbert Stiegel, Dr. C.C. Conrad, Hershey Weaver, Dr. Henry Deyerle, Ed C. Martz, C.G. Price, Jack Reilly, Amos Devier, Frank Whitesel, Frank Taliaferro, Merle Friddle, and Henry Ney; (middle row) T.F. Yager, C.H. Mauzy, John R. Saum, W.H. Keister, T.L. Williamson, E.R. Fletcher, Ernest Wilton, Father William J. Meredith, and Ray Brown; (back row) John P. Burke, Ward Garber, Wade Menefee, T.R. Herring, John R. Crown, Frank C. Switzer, A.N. Wetsel, W.M. Menefee, Albert Lewis, Frank Garber, George Shue, Hank Marsh, S.P. Duke, Dan Wine, Tom Strange, B.F. Garber, Grimes Heneberger, Ed Garber, Page Duke, Dr. E.B. Miller, Hampton Mauzy, Walter S. Gifford, C.A. Funkhouser, Gilbert Spitzer, William Dean, and Boyd Garrison. (Julius F. Ritchie Collection.)

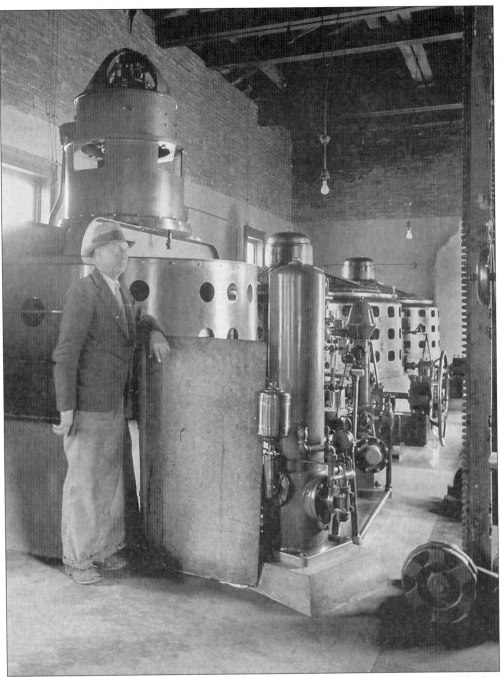

In 1904 Harrisonburg became one of the first cities in the country to have a municipal facility for generating electricity. That power came from a small hydroelectric plant located on the Shenandoah River. In 1924 this plant was supplemented by a steam-powered system that also generated electricity for the city. Starting in 1936, engineers began to revamp Harrisonburg's electrical system, linking the steam and the hydroelectric plants to ensure a steady flow of current throughout the city. In this photograph Bob McInturff pauses while working in the hydroelectric plant. (City of Harrisonburg Collection.)

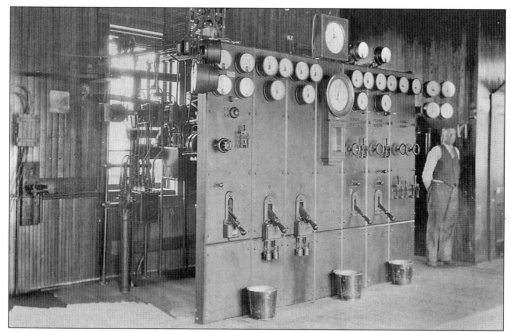

By the time renovations to the system were completed in 1937 nearly $204,000 had been spent. The effort had raised the city's electrical capacity considerably, however, and it had completely modernized their plants. In January of 1938 the *Daily News Record* reported, "The new switchboard inside the building is the last word in such equipment and it is almost mechanical in operations. There is a control for everything and a dial indicating all factors." Here, Bob McInturff demonstrates the effortless control of the new equipment. (City of Harrisonburg Collection.)

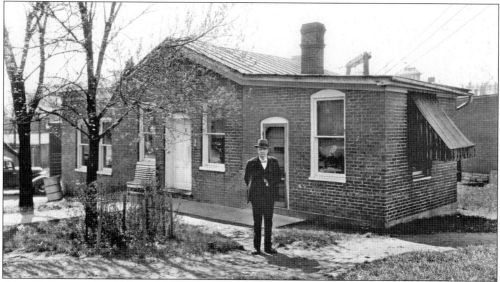

John Noll, pictured here at the municipal substation on East Elizabeth Street in the 1930s, served the city for many years as the superintendent of public works. Noll oversaw many of the projects that brought power to the growing city in the first decades of the 20th century. (City of Harrisonburg Collection.)

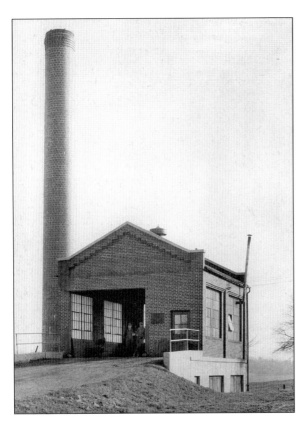

Another of the city's municipal structures was the incinerator, located at the eastern terminus of Franklin Street, where the Kiwanis Park is now located. When this photograph was taken in the 1930s, Eli Bowman (on right) was the operator. (City of Harrisonburg Collection.)

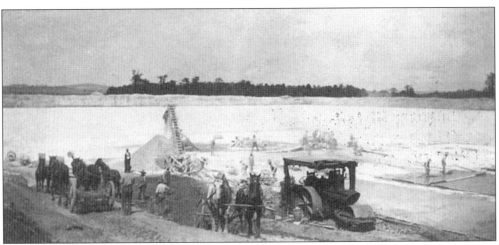

After an earlier reservoir proved inadequate, the Harrisonburg city council sought to locate a new one on the Hill east of the city. Unable to reach an agreement with Mrs. A.M. Newman for property east of Campbell Street, the council finally purchased a tract of land from Rockingham Paul. Located, appropriately, along today's Reservoir Street, the higher property added to water pressure in the city, which aided fire fighters. This photo was taken in 1914 as the reservoir was being built. (Harrisonburg-Rockingham Historical Society Collection.)

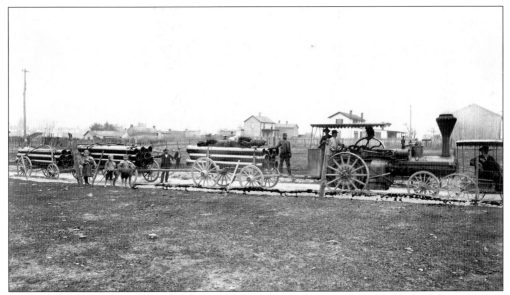

As the demand for water in the city increased, several plans were put into effect to meet the growing needs. The first reservoir was built in the 1880s and early in the 20th century water was piped to the city from Dry River in the Rawley Springs area of western Rockingham County. This unique photograph of an unidentified crew hauling pipe provides a glimpse of the efforts made to bring fresh water to the city. (Julius F. Ritchie Collection.)

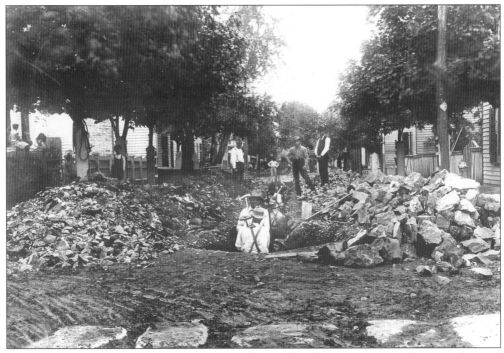

This photograph shows a crew probably at work installing the water main to the central part of the city on North Main Street looking south from the intersection with Rock Street. (Julius F. Ritchie Collection.)

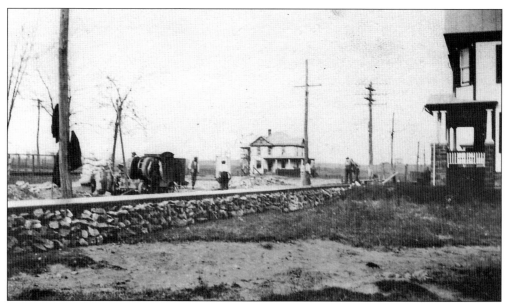

West Street (High Street) north of West Market Street was named Virginia Avenue as lots along the street were sold for residences in the 1890s. The empty space seen here quickly filled with homes, increasing the need for street improvements. (Harrisonburg-Rockingham Historical Society Collection.)

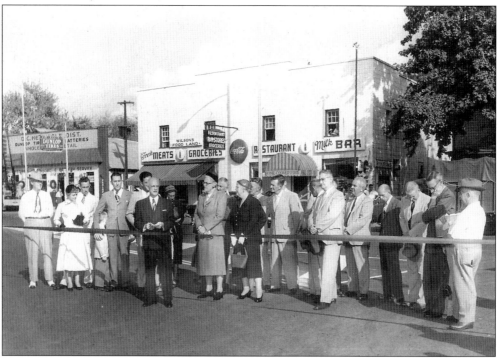

The 1950s official opening of Noll Drive indicated the continued expansion of Harrisonburg's business district. Named for John Noll, the former superintendent of public works who served in that capacity for 35 years, the street is a fitting tribute to the man who oversaw the construction of miles of streets and sidewalks. (Julius F. Ritchie Collection.)

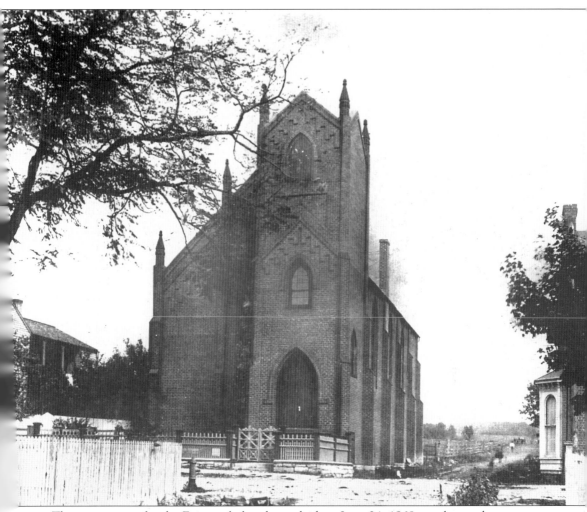

The cornerstone for the Episcopal church was laid on June 24, 1868, on the northeast corner of South Main and Bruce Streets. This photo not only offers an excellent view of the structure, but also provides a glimpse of the empty landscape that extended beyond the building. The church was demolished in 1964 and the site is now the Massanutten Regional Library entrance. (Julius F. Ritchie Collection.)

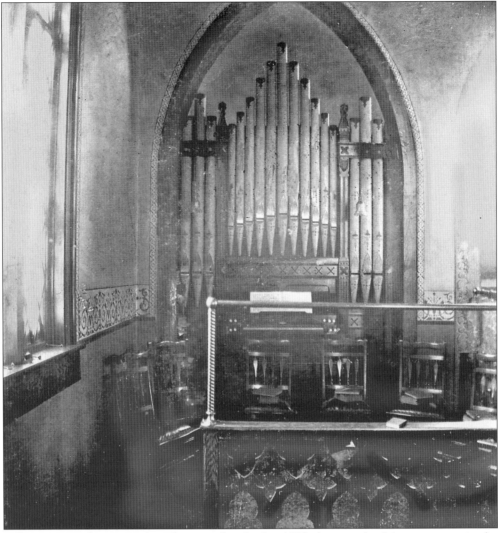

Offering a rare glimpse inside an historic church, this 1899 photograph of the pipe organ in the Episcopal church on South Main Street provides an indication of the decorative details within the church building. The organ was later used in the John Wesley Methodist Episcopal Church on South Liberty Street. (Harrisonburg-Rockingham Historical Society Collection.)

In 1876 Harrisonburg's community of Jewish families incorporated as the Harrisonburg Hebrew Friendship Congregation and by July of 1891 the cornerstone was laid for this temple on the east side of North Main Street. Known as "Bethel," the building was razed in the urban renewal of the late 1950s. (Harrisonburg-Rockingham Historical Society Collection.)

Former Confederate Gen. John R. Jones donated the lot on which the First Baptist Church was originally built. Located on the northwest corner of Mason and East Wolfe Streets, this brick structure took the place of an earlier frame church in 1907, serving Harrisonburg's black community until the urban renewal of the late 1950s. Shot on a picturesquely icy day, this is another image by FSA photographer John Vachon. (Library of Congress, Prints & Photographs Division, FSA-OWI Collection.)

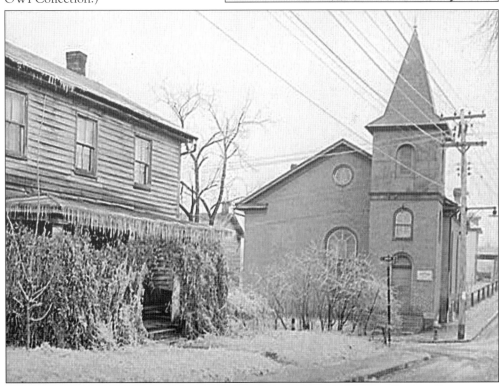

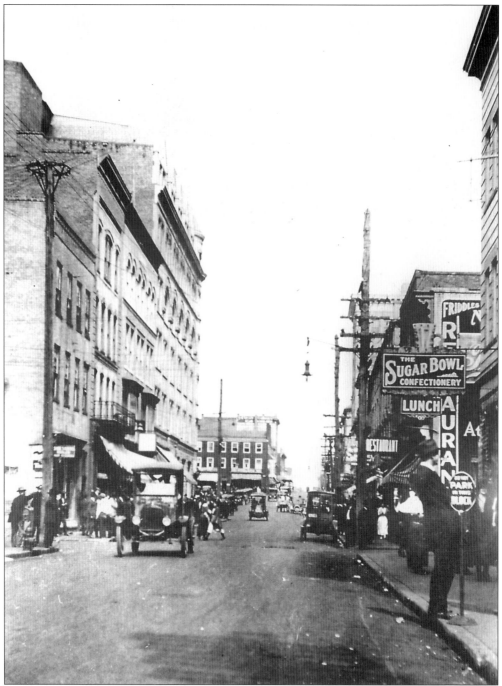

Looking toward Court Square along South Main Street, this 1920s photograph indicates the rise of automobile traffic in the city. An increase in traffic along Harrisonburg's streets eventually affected many decisions regarding the need for public parking for downtown businesses. Often unnoticed, automobiles' requirement of gasoline transformed the fringes of the downtown as service stations began to edge their way into the city's landscape. (Julius F. Ritchie Collection.)

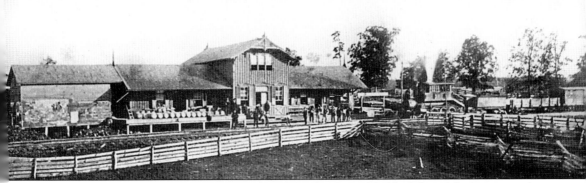

Harrisonburg was isolated from the railroad for the first of half of the 19th century and it was not until 1868 that rails made it to the city. While a group of B&O engineers were surveying the city in 1866, the first train did not run from Harrisonburg to Staunton until 1874. Undoubtedly the station that President Grant passed through in June of that year, the station in this photograph was located west of North Main Street near Kratzer Road. (Julius F. Ritchie Collection.)

Although unidentified, the workers shown here were probably section hands at work on the B&O line north of Harrisonburg in the early 1870s. (Massanutten Regional Library Collection.)

West of South Main Street near Warsaw Avenue, the Chesapeake and Western lines meet with the B&O line and continue heading south. The building in the center of the photograph was the C&W's first passenger and freight station in Harrisonburg and opened in 1895. (Julius F. Ritchie Collection.)

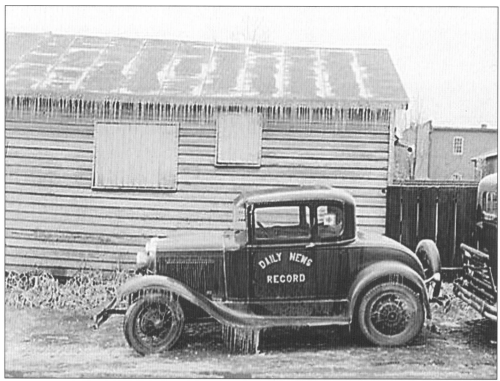

Automobiles and trucks quickly became necessities for businesses, although this *Daily New Record* coupe appears stranded on a wintry day in 1941. (Library of Congress, Prints & Photographs Division, FSA-OWI Collection.)

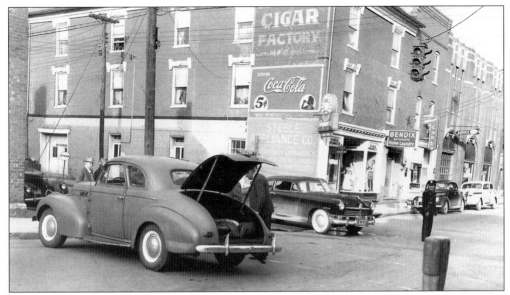

This busy photograph of the corner of West Market and Liberty Streets illustrates a number of things about Harrisonburg in the 1930s. Indicating that headaches caused by automobiles are nothing new, the car in the foreground appears to have broken down. Meanwhile, a city police officer directs traffic, despite the traffic light at the intersection. Perhaps all involved would enjoy a 5-cent Coca-Cola as advertised on the side of the former Hotel Thurmond. (Julius F. Ritchie Collection.)

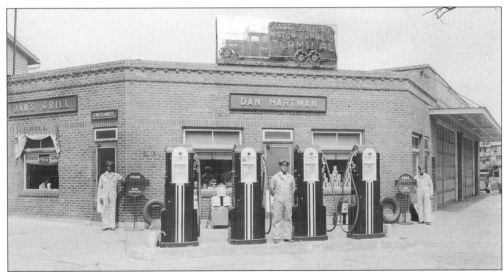

Capitalizing on the opportunities offered by the growing trucking industry, city businessman Dan Hartman started his own trucking firm in the 1930s. At that time he opened the Harrisonburg Motor Express Terminal and Dan's Grill on the northeast corner of North Liberty and West Wolfe Streets. Pictured from left to right in this 1938 photograph are Henry Kayzee, Walter Hartman, and Harold Wampler. (Dwight Hartman Collection.)

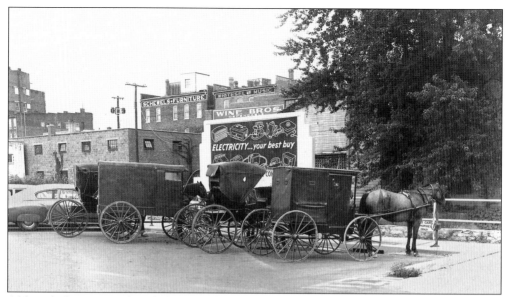

Although the city purchased the former Houck Tannery lot between Water and Bruce Streets and turned it into a municipal parking lot, the transportation revolution introduced by automobiles was not complete. Members of the Old Order Mennonite community from surrounding Rockingham County continued to use public parking for their transportation—horses and buggies. In this 1940s photograph several different styles of buggies are contrasted with what appears to be a Lincoln Zephyr. (Julius F. Ritchie Collection.)

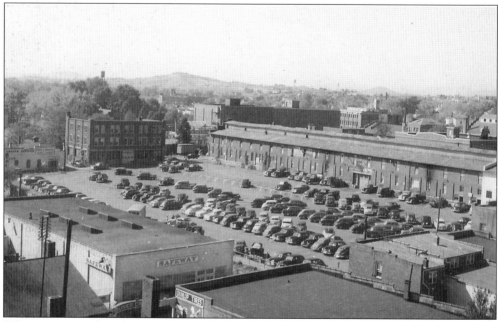

When it was purchased in 1939, only one building remained on the Houck Tannery property. The northern portion of the building, just visible on the right side of the photograph, became the police station, while the rest of the building served as the armory. Later the armory was removed, followed by the northern end of the building. In the 1970s a two-level parking garage was constructed on the site. (Julius F. Ritchie Collection.)

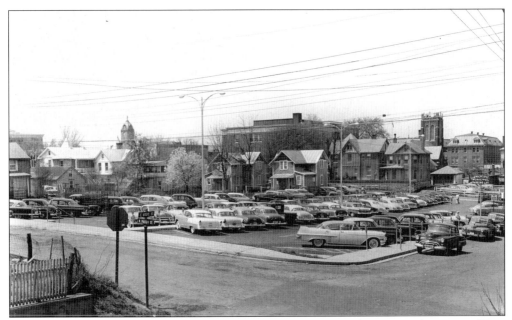

Another municipal parking lot, this one north of Court Square on the corner of Mason and East Wolfe Streets, provided parking within convenient walking distance of Harrisonburg's central business district. The capacity of this lot was also increased with the addition of a second level in the late 1970s. (Julius F. Ritchie Collection.)

Harrisonburg's youth knew where they were headed in the 1940s—to the car lots. Here, posing at the top of Franklin Street, a group of young men proudly display their hand-built "soap box" cars. With a nod toward the commercialism he undoubtedly witnessed around town, the sixth racer from the left emblazoned the name of the local broadcasting station on his car—WSVA. (Jeffrey S. Evans Collection.)

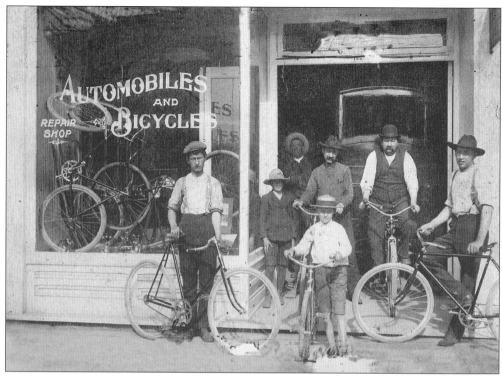

Bob Bradford appears to have had the personal transportation market figured out; he serviced both bicycles and automobiles at his shop on South Main Street. Pictured from left to right are (front row) Carl Roadcap, Norris Bradford, and unidentified; (back row) two unidentified, Robert Bradford, and Newton Finly. (Harrisonburg-Rockingham Historical Society Collection.)

Bicycling was a popular recreation in Harrisonburg by the 1890s, and in this shot Tol Bradford of Lacey Spring poses proudly with his ride. In 1897 the *Rockingham Register* noted that "the wheelmen of the Valley will hold at Assembly Park, Harrisonburg, what is expected to be the largest racing cycling event ever held in this section of Virginia." (Harrisonburg-Rockingham Historical Society Collection.)

Taken by noted Harrisonburg photographer Wilmer Coffman, this extremely rare image documents the first airplane landing in the city, an event that occurred at the Rockingham County Fair in October of 1912. Historian John W. Wayland reported that Charles K. Hamilton flew from the "old horse show grounds, just at the west side of Harrisonburg . . . across the Valley to Peaked Mountain, crossed the Peak, turned and came back, making the round trip of 14 miles in about 14 minutes." (Private Collection.)

In 1938, transportation entrepreneur Dan Hartman opened an airport in a rented field along the Mt. Clinton Pike (Chicago Avenue) on the northwestern edge of the city, later purchasing the property and naming it Hartman Field. Taken in 1942, this photograph shows office secretary Ottie Showalter perched among the Dan Hartman Airways hangers and planes. (Dwight Hartman Collection.)

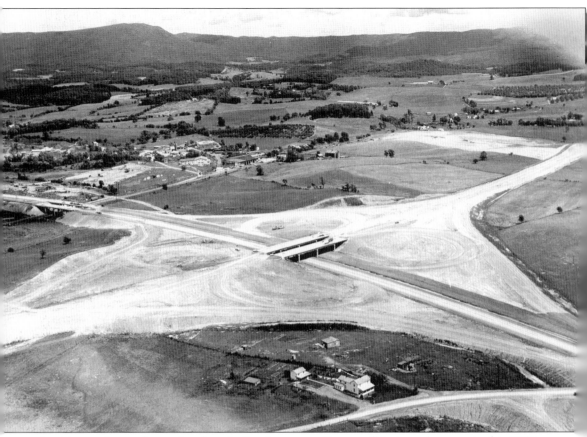

Looking to the northeast, the cloverleaf on Interstate 81 was still in its early stages in this 1959 photograph. In the 1950s city residents had become increasingly concerned about the congestion on their streets caused by the volume of through traffic. Writing on the occasion of the opening of the bypass around the city in 1960, J.R. "Polly" Lineweaver's words sound truly prophetic today. He thought, "This comparatively short link of superhighway is expected to make as great an impact on the development and economy of the area through which it passes and serves as the highway itself has made on the landscape on the eastern edge of Harrisonburg." (City of Harrisonburg Collection.)

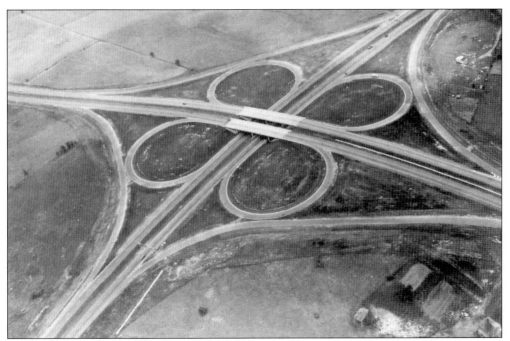

This later view of the cloverleaf, taken from the northwest in 1960, shows the completed project. Built on the Hirsch farm east of Harrisonburg, the entire cloverleaf covers 30 acres. Initially constructed as a 7.5-mile bypass of Harrisonburg, the highway served the purpose of a limited access road until the Interstate was completed through the Shenandoah Valley in the 1960s. (City of Harrisonburg Collection.)

Commercial development did not take long to find its way to the new cloverleaf. Recognizing that folks drove out to the bypass simply to marvel at the novel configuration, the proprietors of the "Cloverleaf Shopping Center" were quick to pave a parking lot and construct a strip mall anchored by A&P and Drug Fair. (Harrisonburg-Rockingham Historical Society Collection.)

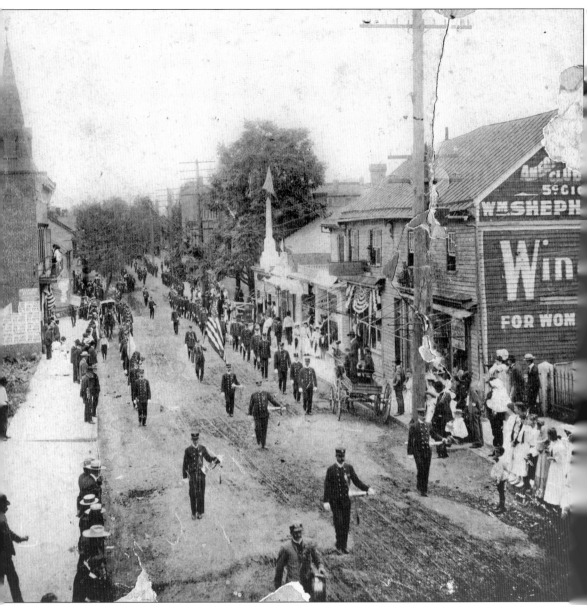

Parades were a welcome diversion for young and old in Harrisonburg for many years. Firemen's parades such as this 1900 event featured regional bands as well as the city's four hose companies. The standard route for these affairs began on West Market Street, progressed around the square, and followed North Main (seen here) to Assembly Park on the north end of the city. (Harrisonburg-Rockingham Historical Society Collection.)

The route has changed, but a parade is still a parade. Stepping out along South Main Street this unidentified band was featured on a summer's day in the 1940s. This image also offers a glimpse at the storefronts along this portion of Main Street. (Jeffrey S. Evans Collection.)

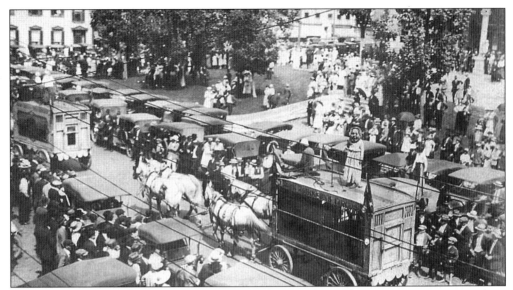

Presenting an interesting juxtaposition, John Robinson's horse-drawn circus wagons pass by a Court Square packed with automobiles. Circuses and their accompanying parades through downtown continued to bring throngs to the city, as this 1912 image attests. (Harrisonburg-Rockingham Historical Society Collection.)

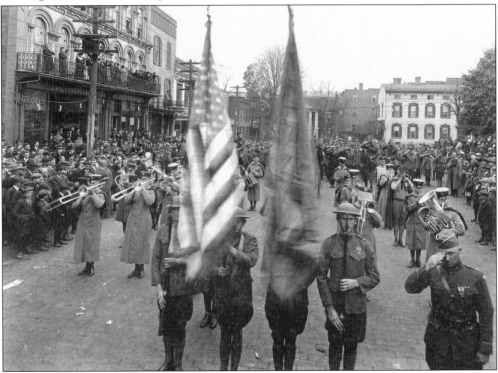

Military parades were popular and Harrisonburg's and Rockingham County's citizens turned out in patriotic support and to enjoy the music. This image from Armistice Day, 1920, demonstrates how important military observances were in the early 20th century. (Jeffrey S. Evans Collection.)

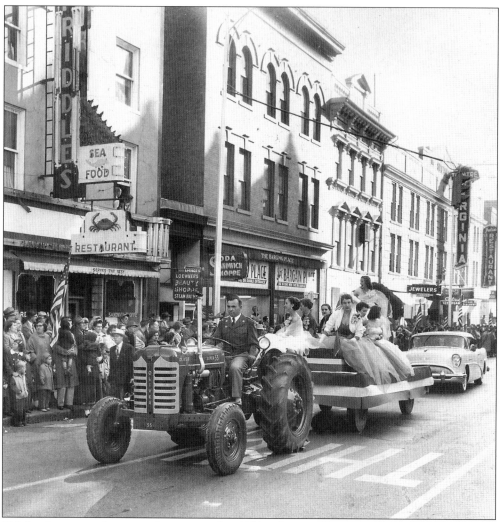

Celebrating an undetermined event in the 1950s, this parade image illustrates a number of points about Harrisonburg. The storefronts along the east side of Court Square reveal the variety of merchants available to parade goers and the tractor-pulled float signifies the important role of agriculture to the city and the region. (Julius F. Ritchie Collection.)

Community bands were popular from the late 19th century into the mid-20th century. Harrisonburg photographer Hugh Morrison captured this band reunion at nearby Mt. Crawford on June 6, 1888. Pictured from left to right are (front row) Tommy K.S. Bassford, William Gambill, and Al Braithwaite; (back row) "Doc" C.H. Witts, Adolph Wise, Jonas Willis, Sigmund Wise, J.C. Miller, Harry Clinton, G. Baugher, C.A. Chandler, and "Prof" Charles Eshman, leader. (Massanutten Regional Library Collection.)

Businesses occasionally sponsored bands as this image of the *Daily News Record* Band attests. Often local bands featured two generations from the same family. (Harrisonburg-Rockingham Historical Society Collection.)

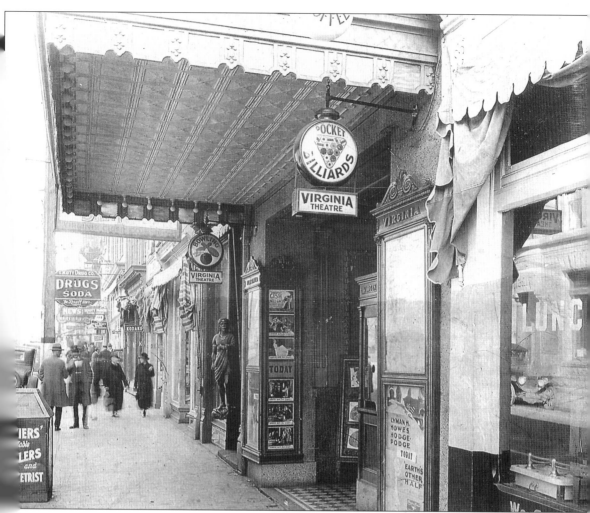

Looking north along Main Street, this nostalgic scene from the 1920s offers a view of businesses located in the Spotswood Building. The mezzanine of the Virginia Theatre marks the spot of two of the city's favorite entertainment venues: the theater itself and the Arcade, which offered pocket billiards, bowling, and eats. The Virginia, in operation until the 1980s, offered not only films and live performances, but also provided a venue for large meetings and notable public speakers such as William Jennings Bryan who lectured there in 1921. (Julius F. Ritchie Collection.)

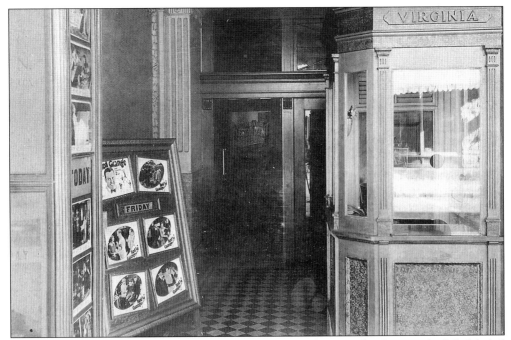

The shared entrance to the Virginia and the Arcade was elegant. The door on the left, labeled "Arcade Restaurant" led down a hall to all of the Arcade's offerings, while visitors to the theater entered behind the ticket booth. In this photo the silent film *Nell Gwyn*, starring Dorothy Gish, was on the bill along with a silent cartoon, *Earth's Other Half*. The release dates of these features suggest the photo was taken in the winter of 1926–1927. (Julius F. Ritchie Collection.)

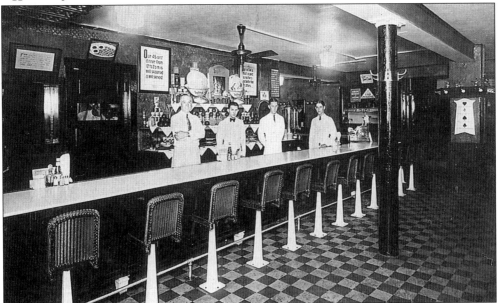

The Arcade offered an entire evening's entertainment. Along with tables and booths, the restaurant featured diner style seating at the bar and a soda fountain was situated across the room from the snack bar. Patrons could have their dinner there and then enjoy bowling, billiards, or pool in the various rooms of the establishment. (Julius F. Ritchie Collection.)

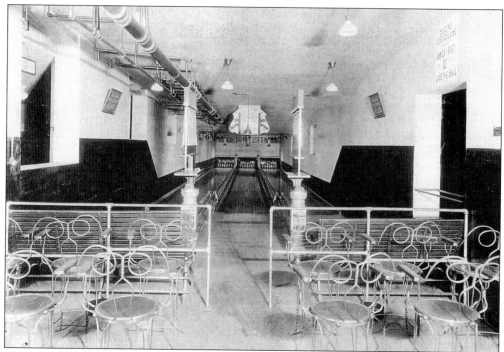

The Arcade also featured bowling lanes with both regular pins and duckpins. This photograph shows the duckpin lanes and the seating gallery with stylish ice cream chairs and tables for spectators. (Julius F. Ritchie Collection.)

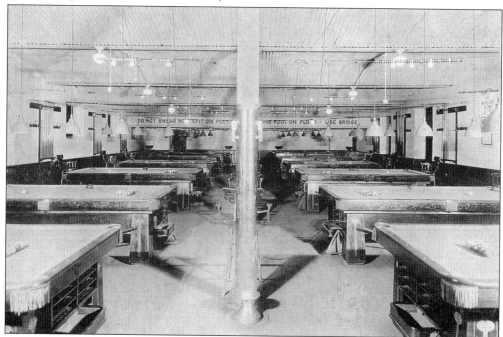

Shooting pool was a popular pastime in Harrisonburg during the 1920s and the poolroom at the Arcade featured a dozen pocket billiard tables. An additional room offered six pocket-less tables for patrons who preferred the three-ball variety of the game. (Julius F. Ritchie Collection.)

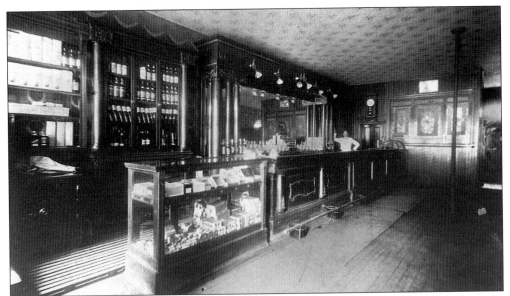

Turn-of-the-century Harrisonburg offered numerous opportunities for those who liked to take a drink. Charles C. Conrad, the Kavanaugh Brothers, P.J. Lamb, Dan O'Donnell, J.H. Savage, John Wallace, and W.H. Willis were saloonkeepers around 1900. The well-appointed saloon pictured here may well be that of the Kavanaugh Brothers, who included a bar in the Kavanaugh Hotel, which opened in 1905. Interestingly, citizens of Harrisonburg and Rockingham County voted overwhelmingly for statewide prohibition in 1914. (Julius F. Ritchie Collection.)

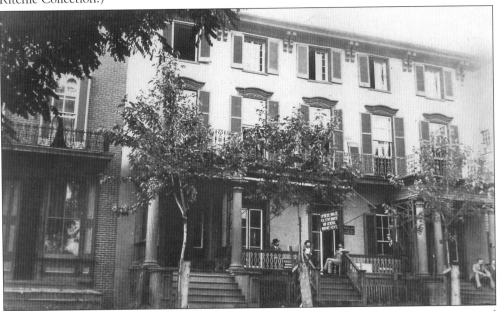

The Exchange House, later the Warren Hotel, housed businesses as well as visitors and residents. Here a group of men lounge on the porch of the Lupton and Sullivan real estate office. Looking back to 1918 or so, Bill Reilly remembered that a favorite Sunday pastime of hotel visitors in Harrisonburg was "sitting in chairs in the lobby and looking out the window." (Harrisonburg-Rockingham Historical Society Collection.)

The Strand Theatre opened on South Main Street in 1934 with a showing of the film version of Zane Grey's *The Last Trail*. Pictured here on the first day of school in August of 1934, the policeman stopping traffic is Robert C. Morrison. Although the theater closed in the 1950s, the building still stands and operates as a bar and restaurant. (Julius F. Ritchie Collection.)

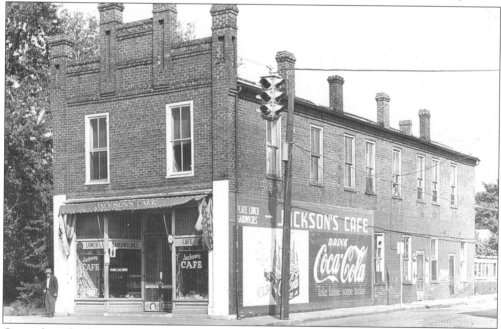

Opened in the late 1920s in this building on the northeast corner of North Main and Gay Streets, Jackson's Café operated at this site until the urban renewal of the 1960s when it moved to another location. E.F. Jackson's restaurant was a landmark in the northern section of the city not only because of its turn-of-the-century brick architecture, but also because, as oral history suggests, it was the only restaurant in Harrisonburg that served both whites and blacks during the era of segregation. (Julius F. Ritchie Collection.)

Aiming to catch the northbound traveler before he came to Harrisonburg's downtown eateries, Howard Johnson's Restaurant stood on Highway 11 on the extreme southern end of the city. When the interstate lured much traffic to its four lanes in the 1960s, the Howard Johnson Company built a new restaurant and motel at the Port Republic Road exit. Taken in 1962, this photograph clearly demonstrates the restaurant's situation in the rural landscape near the city limits. (Harrisonburg-Rockingham Historical Society Collection.)

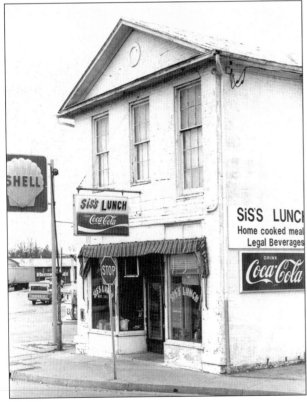

One of the few restaurants on North Main Street to survive the urban renewal program, Sis's Lunch served "Home Cooked Meals" and "Legal Beverages" until the 1970s. The diner was located at the intersection of Kratzer Avenue and Noll Drive, and was razed during Rocco's expansion in the 1980s. (Julius F. Ritchie Collection.)

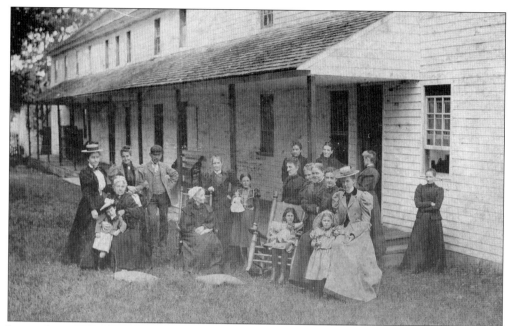

Located near the foot of the peak of the Massanutten Mountains in Rockingham County, Taylor Springs was first promoted as a resort around 1800. In 1872 a mineral water company was formed and the name changed to Massanetta Springs. Supposedly one of the company officials created the name by combining Massanutten with his wife's name, Henrietta. This photograph depicts the Moore and Allebaugh families at Massanetta Springs around 1900. (Harrisonburg-Rockingham Historical Society Collection.)

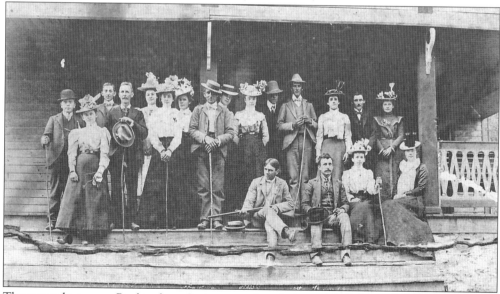

The resort known as Rockingham Springs was founded near McGaheysville in the 1870s and remained a favorite spot into the 20th century. Renowned 19th-century poet Sidney Lanier spent time there in 1879; however, the group in this photograph appears more ready for a fashionable afternoon of socializing than quiet reflection upon a work of poetry. (Harrisonburg-Rockingham Historical Society Collection.)

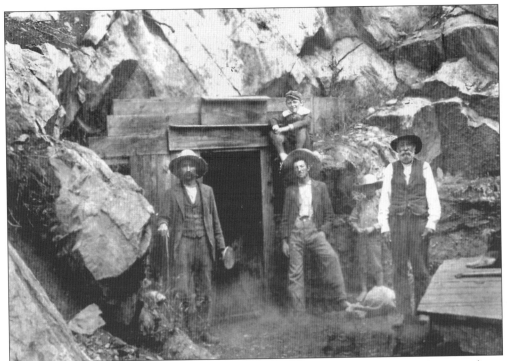

Massanutta Gertrude Cave was discovered in 1892 near Keezeltown, just east of Harrisonburg. Complete with seats and pavilions for picnickers, by 1910 the site was a tourist attraction operated by J.P. and Thomas Armentrout. Harrisonburg residents visited the nearby cavern for a pleasant respite from city life. (Harrisonburg-Rockingham Historical Society Collection.)

Fishing has always been a pastime for many Harrisonburg residents. Recalling his youth, John T. Harris Jr. remembered enjoyable hours fishing in Black's Run in the days before the waste of the city began to find its way into that waterway. In this scene from the 1890s, a group of fishermen takes time to pose before the Shenandoah River. (Harrisonburg-Rockingham Historical Society Collection.)

If indoor activities were more appropriate, many Harrisonburg residents had an ample supply of diversions. In this photograph the Henry Forrer family poses with all the trappings of a Victorian parlor, including a stereoscope for the armchair traveler. The Forrers owned property in Harrisonburg as well as in the county, making the location of this image difficult to ascertain. (Harrisonburg-Rockingham Historical Society Collection.)

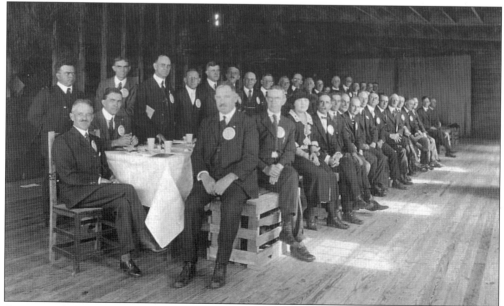

Civic-minded men of the city founded the Harrisonburg Rotary Club on April 1, 1921. In this 1920s photograph club members pose during a meeting held at the Tip Top Fruit Farm, which was located east of the city along Highway 33. (Harrisonburg-Rockingham Historical Society Collection.)

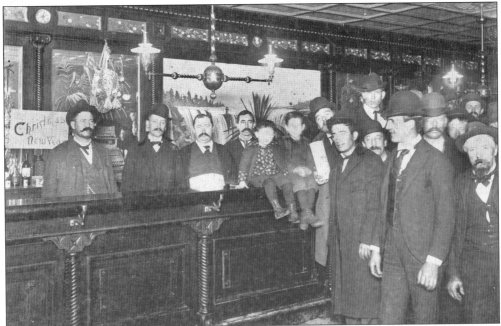

People enjoy celebrating together, and many folks celebrate in bars, as this group did during the Christmas and New Year's season in the 1890s. Pat Lamb, third from the left, operated his saloon on West Water Steet for many years. (Harrisonburg-Rockingham Historical Society Collection.)

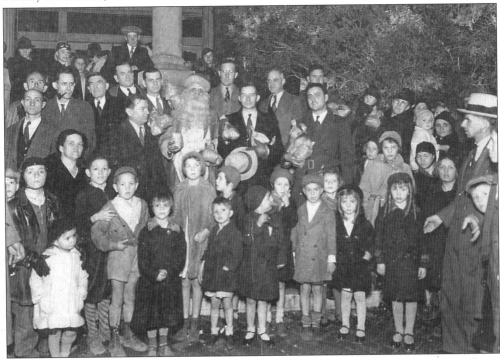

Perhaps a more wholesome group than above, families crowd around Santa Claus on Court Square in this 1950s photograph. (Harrisonburg-Rockingham Historical Society Collection.)

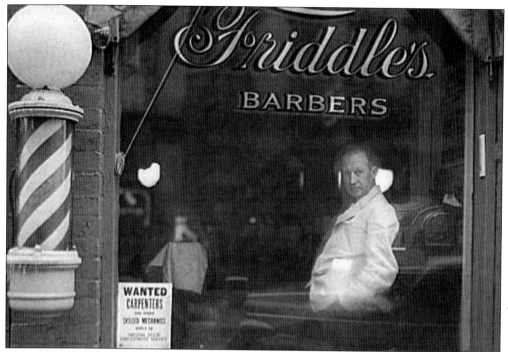

Although barbershops are often considered to be community gathering spots, the barber in this photograph by John Vachon appears to be waiting for customers. Friddle's Barbers were located on South Main Street in the 1930s and 1940s. (Library of Congress, Prints & Photographs Division, FSA-OWI Collection.)

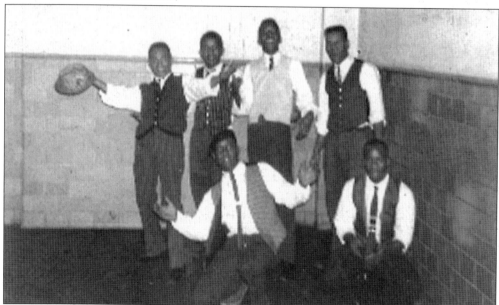

Groups form for many reasons, including singing. Calling themselves "The Lavender," this group of Simms School students performed in the 1950s. Crouched in front, left to right, are Eugene Couter and Jamie Madden. Standing in the back are Alfred Howard, ? Brown, Burton Winston, and unidentified. (Jennifer Vickers Collection.)

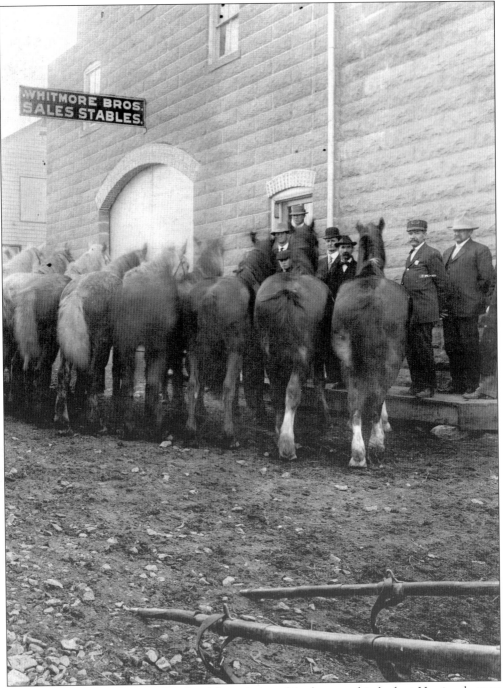

A final shot of the Whitmore Brothers' finest brings this photographic look at Harrisonburg to an end. (Jeffrey S. Evans Collection.)